# SHETLAND ISLANDS

# SHETLAND ISLANDS

JAMES A. POTTINGER

The History Press

First published 2015
Reprinted 2017

The History Press
The Mill, Brimscombe Port
Stroud, Gloucestershire, GL5 2QG
www.thehistorypress.co.uk

The photographs included in this publication are taken by the author
unless otherwise credited.

British Library Cataloguing in Publication Data.
A catalogue record for this book is available from the British Library.

ISBN 978 0 7509 6002 1

Typesetting and origination by The History Press
Printed and bound by Berforts South West Ltd, England.

# INTRODUCTION

Firstly, I will open with a disclaimer: there is no such place as 'The Shetlands', any more than there is 'The Orkneys'. There is, however, the correctly named Shetland Islands or Shetland, and Orkney or Orkney Islands.

Shetland has seen inhabitants ranging from Mesolithic, Neolithic, Pictish and Viking eras. All have left their mark but the latter have had the longest-lasting influence, particularly in terms of local place names (although these are mingled with a number which are obviously of Pictish origin), certain aspects of dialect, and descriptive terms for boats and the sea.

Climatically, its temperance is wholly due to the benign influence of the Gulf Stream; long-lasting frost and icy conditions are rare, and winters are not as cold as those in Scotland and England. The downside, in a statistic unique in Britain, is that the temperature has a daily maximum difference over the year of a mere 8°F. Thus heat waves in summer are equally rare, and when it does blow, it certainly does blow – prolonged gales and gusts of 100mph or more are not unusual. On the upside, some sixteen hours of sunshine have been recorded in summer – the consequent twilight being termed the 'simmer dim' – in contrast to the dark hours of winter, which can last from 4 p.m. to 9 a.m.

Shetland has always been positioned at a crossroads in terms of its geographical location. Initially a stop-off place for the Scandinavians (to whom many owe their direct ancestry) in their westward excursions to the shores of Faeroe, Iceland, Greenland and ultimately to America, Shetland later became a permanent settlement and also a roadblock between the north of Scotland and Norway when German naval forces were seeking to choke the maritime lifeline between the UK, Canada and the USA during the two world wars.

Wars saw the cream of the islands' lifeblood pay the ultimate sacrifice on land, sea and in the air. In the First World War, one in every thirty-two Shetlanders perished, and in the Second World War the toll was one in every seventy. Winston Churchill's comment that no part of the Empire had suffered

greater losses than the Londoners (with one in every 140 being killed) was greeted with some raised eyebrows but no great surprise.

Service in wars was nothing new for Shetlanders – after the Battle of Trafalgar it was believed that around 3,000 Shetlanders were serving in the navy, a surprisingly high figure, particularly since the population was then less than 10,000. Many joined willingly, or out of an economic necessity born of trying to make a living in depressed times, but many others were press-ganged into service – a consequence of their proven skills in boat handling and general all-round ability afloat.

Whilst modern farming methods have increased the yield from, at best, comparatively poor soils, the economy of Shetland has always depended on the rich fishing grounds surrounding the islands. Each generation of fishermen has adapted to take advantage of the changing patterns of economics, boat design, the types and habits of the pelagic and demersal species and shellfish, and now the increasing importance of salmon and certain types of shellfish farming. An unexpected bounty offshore – which has now been augmented by the significant infrastructure and increased employment on shore in the capital installations and associated service industries – is due to the close proximity of a totality of oil and gas sources as yet undetermined.

Shetland has unwittingly, therefore, gained newfound economic importance for Scotland, which could have led to some intriguing scenarios if Scottish Independence had received a favourable majority. The old saying, that the only thing to come into the 'sooth mooth' (the south entrance to Lerwick) was 'dear meal and greedy ministers', perhaps reflects how many Shetlanders may feel about this. In fact there is a well-documented historical antipathy to some aspects of Scottish central rule, mainly as a consequence of the imposition of rapacious lairds from the south not noted for their munificence (to put it mildly). The islanders are ever mindful of their more benign Norse heritage.

The photographs featured in this book are all ones that I took in Shetland, with a few exceptions. The reader will notice a bias towards scenes of West and East Burra, and especially Hamnavoe on West Burra, this is possibly understandable, given that I spent an idyllic childhood in these localities. When not at school, the first thought was to go down to the pier, a few hundred yards away, with a baited line for catching fish or crabs, or out in our boat, or to play football or other outdoor games and pastimes, a pattern common to most schoolchildren of that era.

Another reason for this bias is that Hamnavoe and Burra perfectly exemplify the changes that have followed in the wake of different fishing patterns. Where once they were home to a large fleet of inshore fishing boats – working on a pattern of fish during the day and then landing the catch at nearby Scalloway,

all in a twenty-four-hour cycle – now fewer large boats operate and the catch is landed at any suitable port in Shetland, with trips sometimes lasting days rather than hours. Another fundamental change has been wrought by the coming of the bridge connecting the islands to the Mainland via the link at Trondra; previously, it was necessary to leave Burra in order to attend higher education at Lerwick and this inevitably resulted in some of the populace drifting away. In the days of the small Hamnavoe–Scalloway ferry, everyone knew who was coming and going, and the local shops served as a popular meeting point. Now the workforce can easily travel to employment and it is possible to shop further away. This has resulted in a stabilisation (or increase) of the population, as shown by the numerous new houses being built.

Burra Isle, which comprises West and East Burra, has always looked to the sea for sustenance. Although the isle is home to some crofts, the soil is unforgiving and its original development and permanence is largely due to the bounty afforded by the Burra Haaf fishing grounds extending from near the shore to as far as Foula, providing herring in the summer and white fish in the winter.

Hamnavoe, sheltered by the protective arm of the Hurds and Fugla Ness from the full impact and fetch of the Atlantic Ocean, is one of the best natural harbours in Shetland. However, changes in fishing patterns and the impact of larger boats means that it no longer forms the base of a large fleet of fishing boats, although it is still home to many fishermen.

Its ideal situation, in respect of the near fishing grounds, was recognised around the end of the nineteenth century with the establishment of a fishing village. The village is unique in that it has relatively closely packed houses with particular regularity, in contrast to the more widely spaced crofting hamlets as seen in other parts of Shetland.

This work is not intended to be a comprehensive gazetteer or guidebook to Shetland. Instead it is a celebration of the wonderful scenery and spectacular vistas seen around Shetland, all too often taken for granted in the round of daily activities.

As a long-time exile, it is hoped that any errors in the text will be forgiven.

Welcome to Shetland. The motto means
'With Laws Shall the Land Be Built' and is also
the adage of the Iceland police force and so
appears on some buildings in Scandinavia.

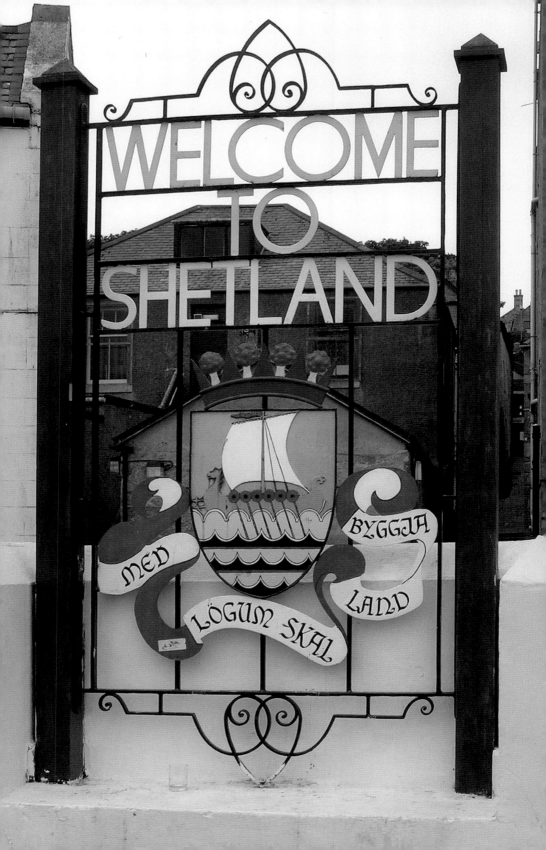

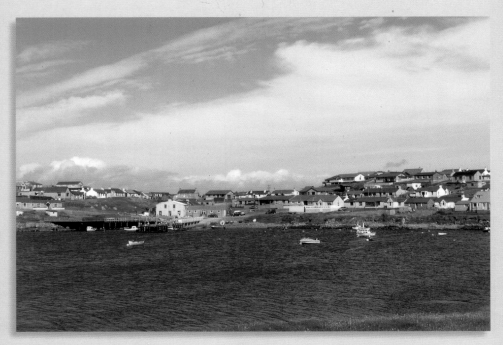

Hamnavoe from the south. This photograph was taken before the marina was built and there is evidence of the many new buildings and extended older houses, which are now an almost universal feature in the area. The yellow frontage of the long-established Halcrow's shop and post office is prominent at the head of the pier; the current concrete pier replaced the original wooden structure in 1956.

The new marina extends almost across to the opposite shore, filling the space where small boats were formerly moored off the beach.

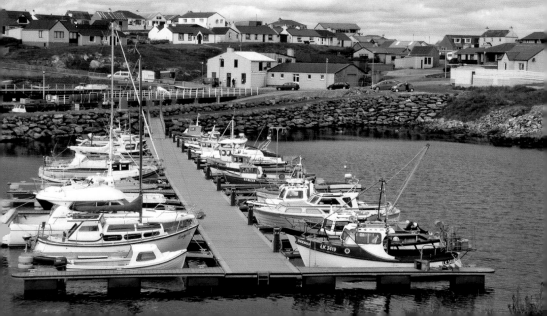

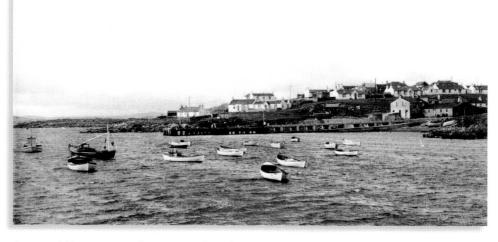

A view of Hamnavoe in the 1960s, when there was a large number of typical Shetland boats moored in the Voe, most having been built by the local builders: the Duncan brothers. By then most had been converted, with inboard engines installed, the 1.5 and 4bhp Stuart Turner petrol engines being popular.

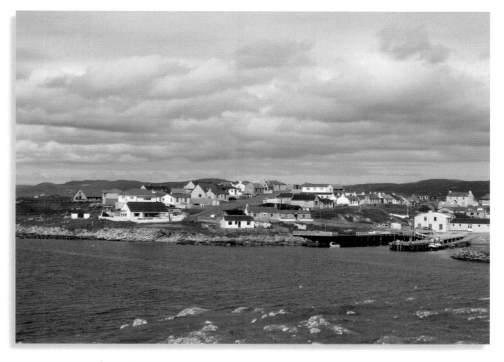

A current view shows that the buildings on the left of the previous image have been replaced with modern bungalow-type houses. The prominent cream-coloured building is the only surviving local shop and post office, with the old boats store adjoining; this is now used as a store for the shop.

This photograph shows the other beach and noosts in Hamnavoe at Bakkaburn, used for drawing up the boats and winter storage. The grey, wooden building on the left is the Duncan's boat-building shed, where most of the traditional Shetland boats seen here would have been built. The square concrete structure in the centre is the well from a natural spring; it was used, either by hand pump or dipping pails, before the advent of a piped main supply.

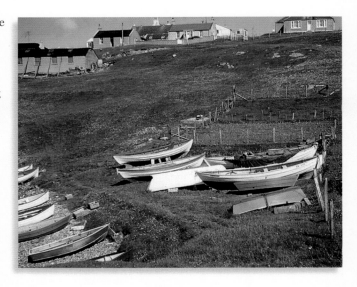

Before the advent of indoor swimming pools, generations of Hamnavoe children learned to swim in the Muckle Loch. This is a natural fissure on the west side of Burra; it is exposed to the wild Atlantic and, at high tide, a slosh of chilly water was often deposited in the slightly warmed pool. The north end was slightly dammed by concrete to raise the water level in the pool.

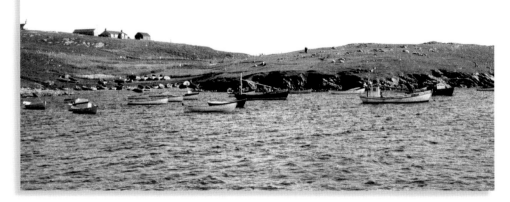

Looking south from the pier, with boats moored in the area now taken up by the marina. It is noticeable in this 1960s photo that the boats are exclusively of the 'Shetland model' type, with no GRP craft.

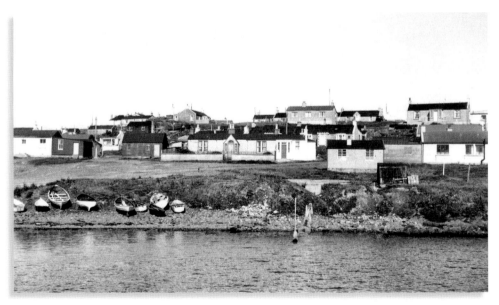

A view of Beach Hamnavoe in the 1960s. From left to right: James Pottinger's general store; a boat gear shed and net store; a similar shed with a black roof belonging to my grandfather; a wooden beach villa, home of my grandparents; my parents' light-coloured house frontage; Hance Smith's milk shop. Beyond these appears the garage belonging to A. Halcrow's general store and carrier – the old wooden shed is a reminder of a row of these at the beach head used to store fishing gear. The beach was used for hauling out 'yaggers' – the small boats used for going out to the fishing boats moored in the Voe.

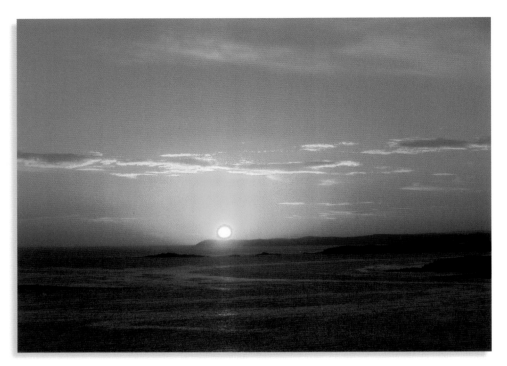

One of the advantages of living on the west side of Shetland is being able to enjoy some
glorious sunsets. In July the sun sinks over the distant Skelda Ness on the Mainland, about
5 miles to the north west of Burra.

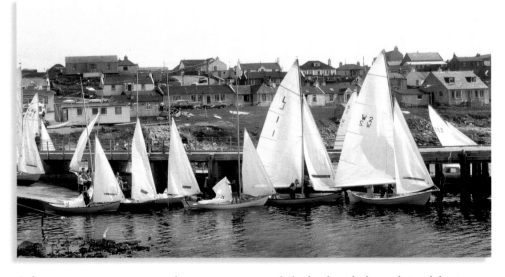

Sailing regattas were once popular in various parts of Shetland, with the traditional dipping
lugsail and also the fore-and-aft rig. Here at Hamnavoe, the prefix letter indicates the locality –
'L-' for Lerwick, 'W-' for Whalsay, 'B-' for Baltasound and 'M-' for Mid Yell. Initially, ballasted
working boats were used, but these were later replaced by purpose-built, unballasted 'Maids' of
finer lines, deeper garboards and nylon sails to enhance windward ability.

A reminder of the days when all local fishing boats berthed at Hamnavoe – in this picture they are rigged for the summer herring fishing. Left to right: *Radiant Star LK 71*; *Press On LK 173*; *Gratitude LK 173*; *Scotch Queen LK 332*; *Golden Harvest LK 53*. The small *Forward* was our family boat, built by Walter Duncan Senior in 1940.

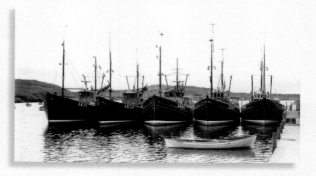

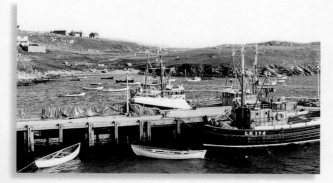

A scene showing seine-net boats berthed at the Hamnavoe Pier. The heading of the small boats moored indicates that a north-westerly wind was blowing. As a child, the author lived for a few years in the prominent house on the top of the hill.

As dusk lengthens, the sky gradually reddens and casts deep shadows. Fuglaness Lighthouse stands sentinel while a lone fishing boat enters Hamnavoe as the last of the daylight slips away.

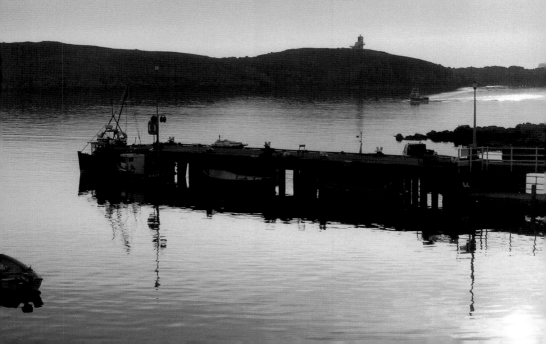

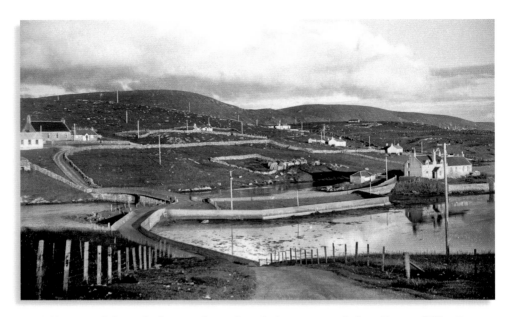

A 1960s view of the Mid Isle at Bridge End, with the causeway linking East and West Burra. The former school sits on the promontory at the head of the South Voe; in 1931 the intake was 137 pupils. The Baptist church, on the hill at the extreme left, was built in 1904 with John Inkster's shop in front. Modern houses have now been built on the site of the ruined cottages and stone enclosure.

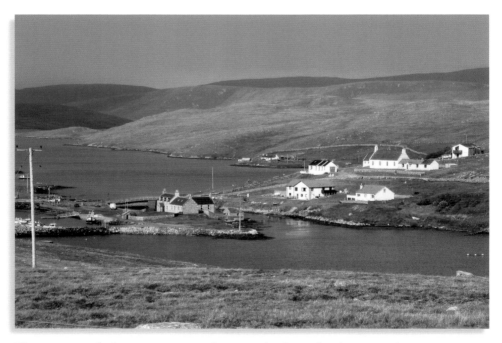

This picture, with the new marina on the west side, shows the changes to this area. The former school is now used for a community centre and has accommodation for various outdoor activities. The building with the red door was formerly a general merchant's shop.

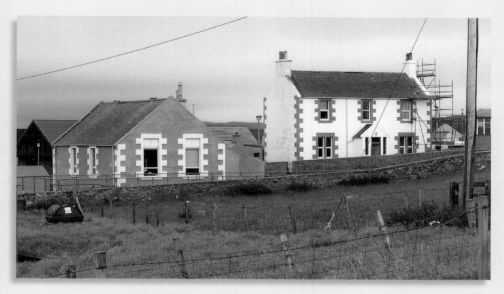

The original two-room Hamnavoe primary school, with the headmaster's house on the right. This house had a large garden on the south side and I recall we used to plant and look after vegetables and flowers on this ground when I attended the school. The boys' playground was on the end facing, and the girls' on the other side.

Setter, on West Burra, nestles at the head of the inlet and is lit by the evening sun; again older croft houses have been extended and modern bungalows added. The word 'Setter' is a derivative of the Norse *bolstaôr*, meaning farm. In the distance, windmills can just be discerned on the hills behind Scord Quarry, overlooking Scalloway.

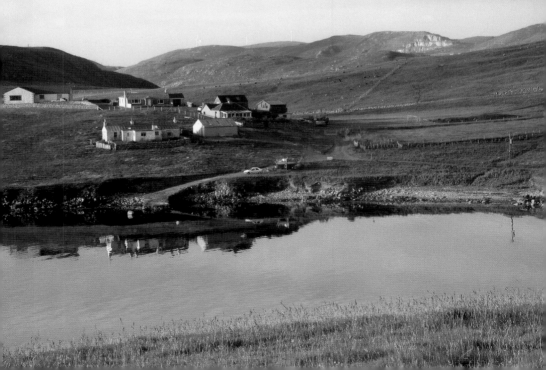

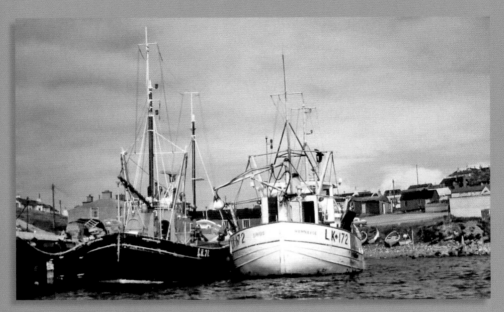

The locally owned boats *Radiant Star* and *Sirius* are tied up at Hamnavoe Pier. The advent of the bridges to the Mainland now means that they can lie overnight at the Scalloway or Lerwick fish markets, which allows the crews to commute.

An unexpectedly calm and tranquil scene at Hamnavoe, with the reflections of the moored boats mirrored in the water.

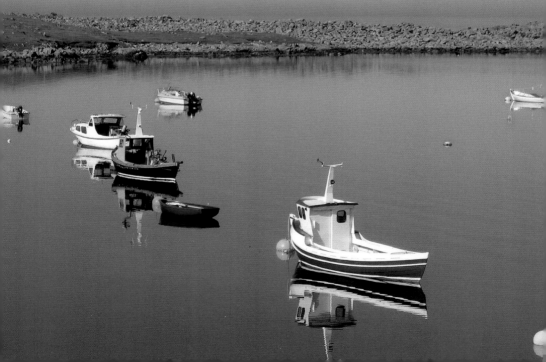

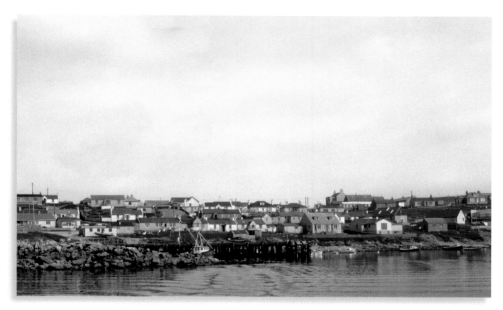

With its houses in serried rows, Hamnavoe is unlike any other village in Shetland. Where possible, houses have been built facing west and therefore enjoy the best of the sunshine.

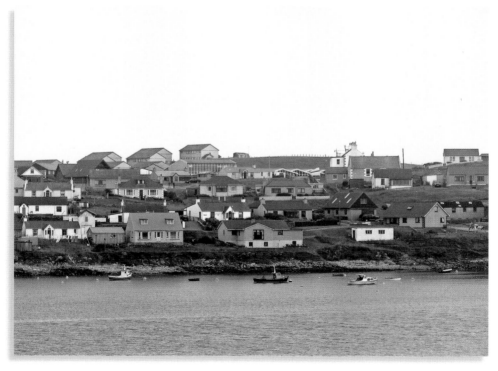

This scene captures the full gamut of traditional houses. Now greatly updated, modern bungalows and villas fill the available space.

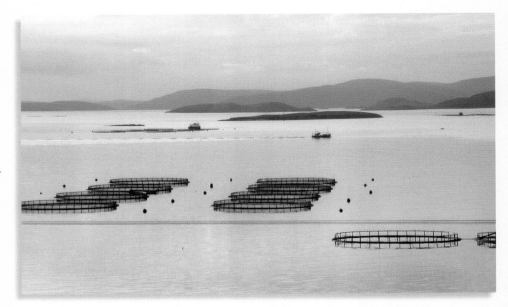

There has been an enormous expansion of salmon farming in Shetland, with cages moored in reasonably sheltered waters; an automatic feeder barge can be seen beside the furthest installation. The seine-net boat *Comrades* makes her way inward to land her catch at Scalloway, one of the last boats to work on the overnight pattern of landing each day.

Prior to the coming of the marina at Hamnavoe, the small boats were all moored at the more sheltered areas to the south and inner section of the Voe. In this view, the traditional wooden 'Shetland model' type still greatly outnumbers the GRP craft.

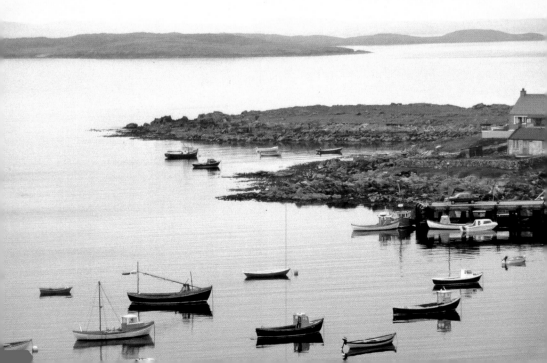

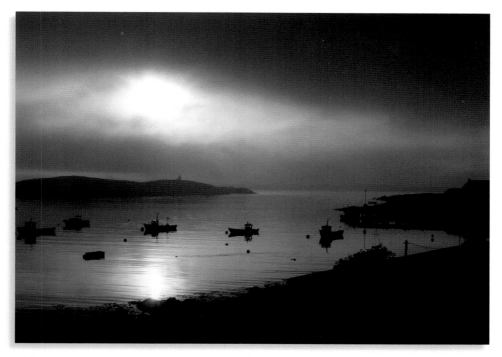

Although it is near midnight in Hamnavoe, these high latitudes still afford sufficient light for photography.

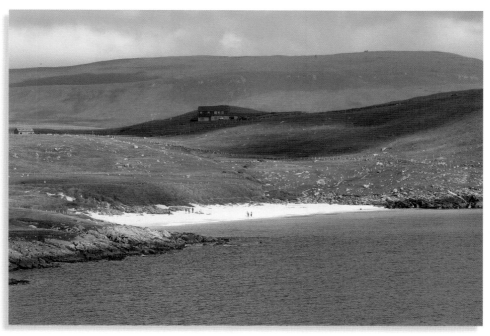

The sandy beach at Meil, West Burra, is one of the most spectacular in Shetland, and has become a popular spot for numerous visitors, particularly since the coming of the bridges to the Mainland. Composed solely of crushed shells, it is dazzlingly white in the sunshine.

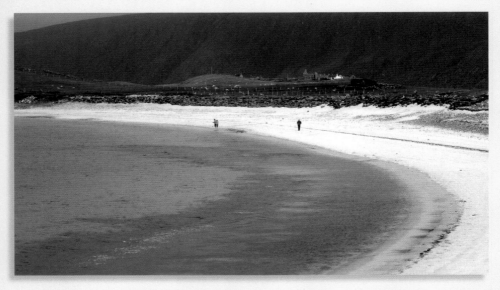

The sands at Minn are striking, with a crescent of white, crushed shells fringing the westerly edge of a narrow isthmus to the most southerly part of West Burra.

Ayre Dyke is a 'narrow neck' linking East Burra and Houss Ness. The small settlement of Houss sits in the centre, with the ruins of the large Haa prominent, and Bridge End beyond. This crossing provided a causeway to the houses at Symbister at the south end of Houss Ness.

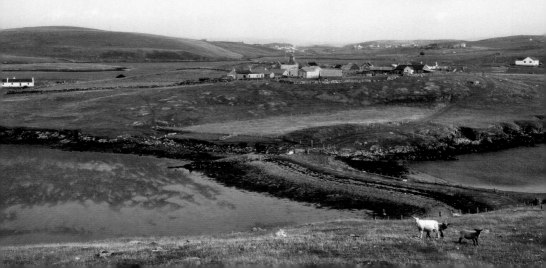

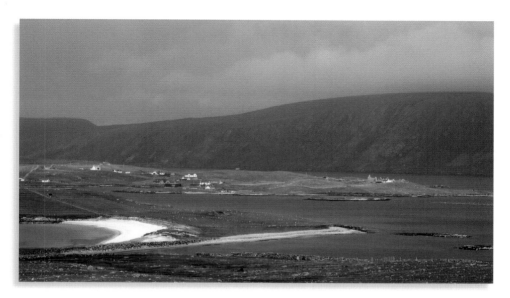

Only a small rocky track between the South Voe and the Atlantic Ocean gives access the now-deserted crofts at Gussigarth. The dominant bulk of the Clift Hills overshadows Houss across the South Voe, with modern houses contrasting with the original, small crofting houses, and the ruins of the two-storey Haa at Houss still prominent.

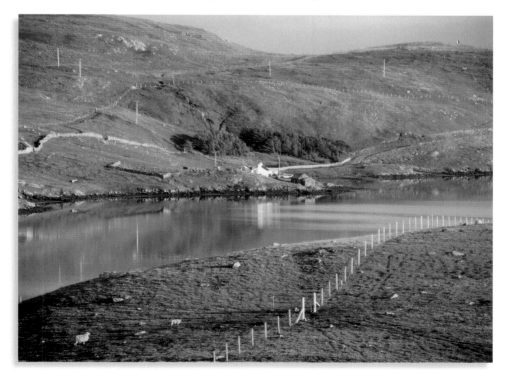

Late sun catches an isolated house at the 'Crô', East Burra. In Shetland this word usually indicates a small stone-built enclosure used for growing vegetables. Alternatively, the location may have taken its name from an area used to herd sheep.

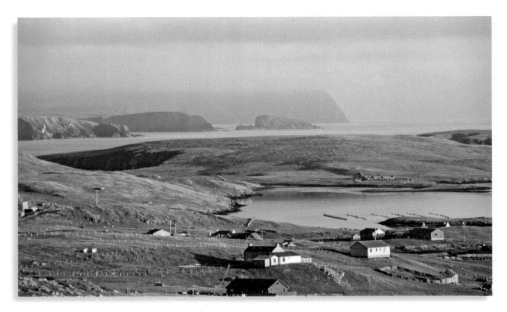

In the centre distance, the ruins of the houses at Symbister, at the south end of East Burra, emphasise its isolation. This seclusion resulted in a 2.5-mile hike each way for children attending the school at Bridge End. The lack of a proper access road hastened the departure of the last remaining occupants. In the distance, the bulk of the Holm of Maywick, and the Fitful Head beyond, loom through the mist.

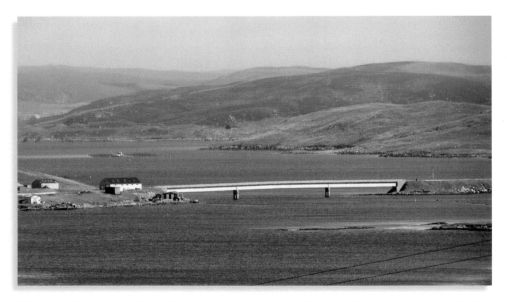

This is the Burra–Trondra bridge which, along with the Trondra–Mainland section, linked these islands with the rest of Shetland. Opened in 1971, the bridge proved a boon in many ways – including reversing population decline and replacing an exposed ferry connection to Hamnavoe – however, it also wrought many changes to the patterns of life on these islands. The significant increase in traffic is one result, and the single-lane roads are often congested.

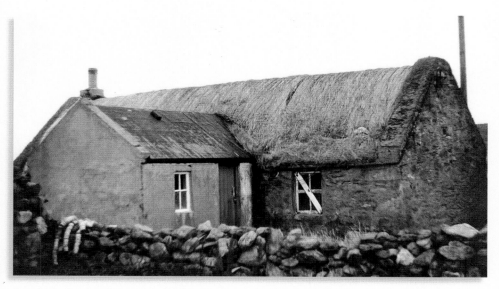

This is the house of my grandparents. Internally it was a 'but-and-ben' cottage, like many old residences in Shetland, with a small room at the back with bunk beds. The extension was only added in the late 1940s.

The current ruins of the above house; this shows the very thick gable-end walls and minimal mortar pointing. The but-and-ben end had only one small window in each room.

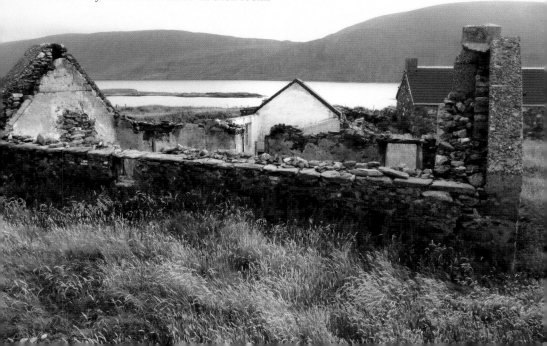

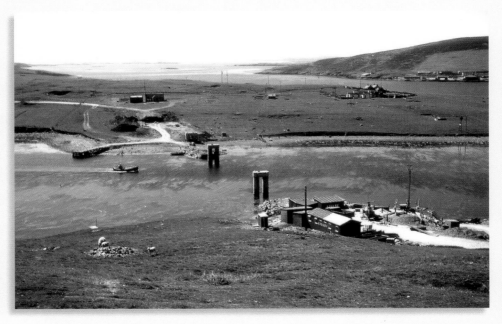

A view taken from the Shetland Mainland while the bridge from Trondra was under construction. (Courtesy of Jack Moar)

The Trondra end of the bridge. The numerous new buildings are evidence of the popularity of the island now that there is an easy commute to the rest of Shetland. The isle of Trondra lies just across the channel from Scalloway, and is now a stepping-stone to the Burra Isles (seen here on the raised ground in the background) by virtue of the 1971 road bridge (extreme left). This bridge has had a similar effect on Trondra as that on Burra, and both localities have, in many ways, assumed the role of 'dormitory towns' for workers travelling to other parts of Shetland.

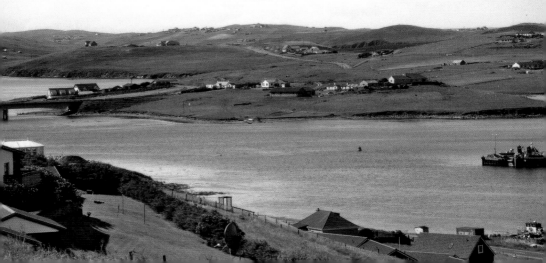

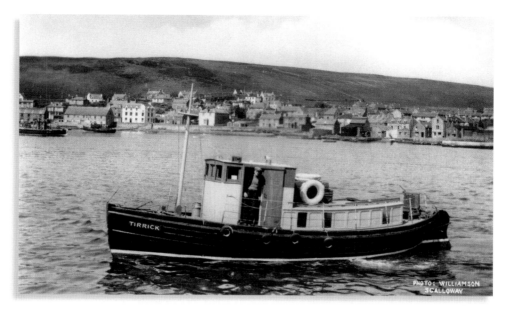

This photograph captures *Tirrick*, a former ferry, on the Northern Isles crossing. The service (providing transportation from Scalloway to Hamnavoe on the isle of Burra) ran for many years and a full-height wheelhouse was later added. The advent of the bridges in 1971 eventually rendered the ferry redundant. (Author's collection)

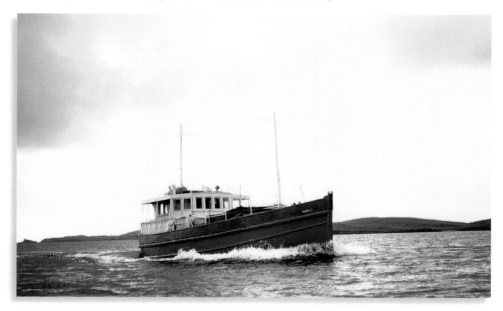

The *Hirta* was built as a fishing boat at Banff in 1920, at times fishing from Fife and later from Eyemouth. She was well known as the Shetland *Surprise LK 188* and, after being damaged when stranded, she was bought by the ferry operator, Hance Smith, who converted her into a ferry-cum-excursion vessel, taking trips around Foula. Later converted into a motor yacht based at the Moray Firth, she was then left derelict and is now probably in her last berth, partly dismantled, at Macduff.

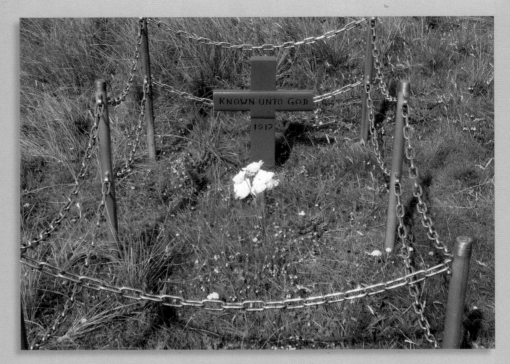

This marked grave is believed to belong to a German seaman whose body was washed ashore on the Meil Sands during the First World War. The continuing respect shown to his resting place is evident, with a new marker and chain replacing the original wooden cross.

Papil in West Burra is one of the nine *Papar* place names in Shetland, a term given by the Norse to the early Irish settlers. It was here, beside the original church, that a large stone engraved with four priests and an animal was found in 1877. The stone is believed to date from the period AD 800–1000. Only a ruin of the original church remains beside the later structure, illuminated by the sun in the west.

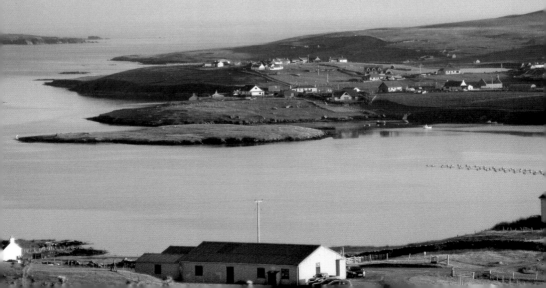

The only reasonably sheltered landing place on South Havera is North Ham, and all goods had to be transported on and off the island from here. It has a south-east aspect and some protection is provided by the Mainland, as can be seen by the confused seas outside the mouth. The radio beacons on the Ward of Scousburgh can be seen in the distance.

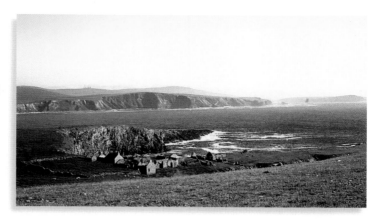

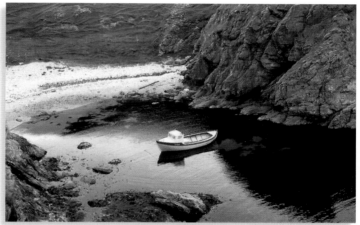

The islands of South and Little Havera lie about 1 mile south of the southern tip of Burra. The last family left the islands in April 1923 and the land is currently co-owned by five landholders who still keep sheep there. Whilst the beach at North Ham provides a useful landing place, a steep hill has to be climbed to reach the ground above. The boat moored in this picture is my brother's and it is possible to climb ashore directly on to the rocks here.

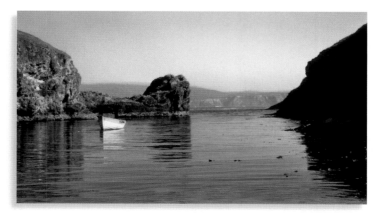

This image shows the narrow sheltered opening of North Ham, the only safe landing place on Havera.

Possibly unique in Shetland, a windmill was built here, on the highest point of Havera, in 1866. The remains of the original windmill can still be seen on top of the hill.

Land suitable for crofting was concentrated mainly on the south end of Havera and houses were built so close to the cliff edges that young children were tethered by ropes, with stakes driven into the ground to prevent them falling over the edge.

There is still evidence of the considerable activity associated with the stone quarry on the island of Hildasay (Norse for Hilda's Island), where stone was carried along a small railway track to a loading berth; some is reputed to have been sent to Australia. On one visit, I spotted a small section of the rails jutting out from under the stone pile. Hildasay has provided peats for householders at Burra and Trondra for many years, there was also once a herring station there.

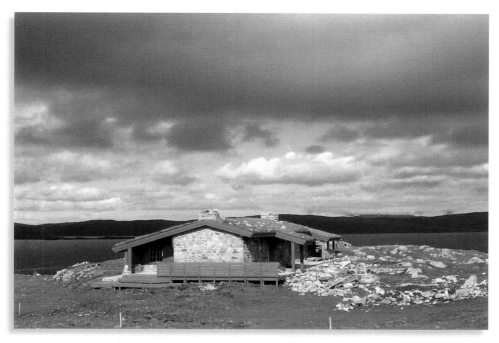

An unusual summerhouse on Hildasay; a far cry from the type of houses the thirty inhabitants who lived there up until 1901 would have been used to. Along with the decline in herring fishing, the quarry also became uncompetitive, leading to the increased use of concrete.

Maywick Beach is 2 miles north of Bigton and a sheltered spot from all directions apart from the north. Projecting at left is the Taing of Maywick (then the isle of Havra) with a windmill on the summit, the dark shape of the Holm of Maywick and the south end of East and West Burra appear beyond. (Courtesy of Joe Gray)

Almost always visible on the horizon, unless hidden by mist, is the looming mass of Foula. Situated some 15–20 miles from the Shetland Mainland, its name possibly originated from the Norse *Fugley*, which means island of birds, and certainly it possesses an awesome sea cliff – the Kame. At 1,246ft above sea level, the cliff is only a few feet shorter than those at St Kilda, which has the highest sea cliffs in Britain. Foula is still home to a varying number of hardy souls whose isolation in now lessened by a regular passenger flight.

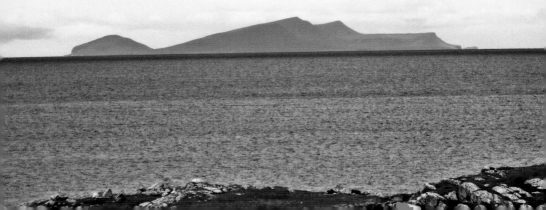

An enlarged view of the southern end of Foula, now with a solar- and wind-powered lighthouse beacon at its tip, and with the Noup rising behind the flatter area on the east side. It is on this ground that an airstrip was levelled off by the islanders. Foula is home to a classified sub-species of mice, the *Mus Thulensis*, which are larger than those that appear on the Mainland.

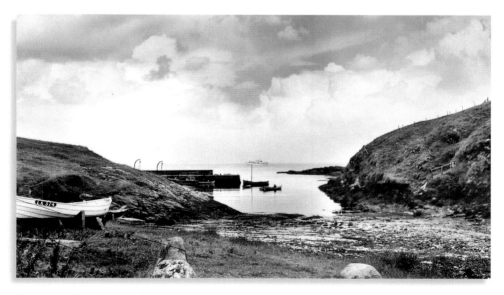

Ham Voe of Foula, a landing place for the ferry. The exposed location, combined with strong tides during the winter months, means that boats are required to be lifted to safety by suitable davits, dependant on the design of the vessel. The original pair of davits are visible in this photograph. (Author's collection)

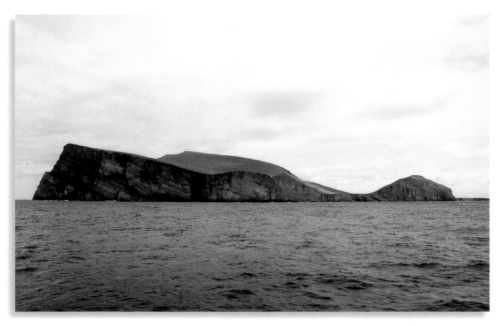

The Noup. Approaching from the south, the Noup presents a forbidding foretaste of the heights of west Foula, dipping down to the prominent hump of Hord Head. (Courtesy of Leslie Tulloch)

Kame. Whilst Sneug – at 1,377ft high and some distance inland – is the highest point in Foula, the precipitous sea cliff of Kame is on the western shore. The bulk of the island is such that on a clear day it can be discerned from Orkney, as confirmed when the Roman Tacitus declared that Agricola's fleet had even seen Thule – *dispecta est et Thule*. (Courtesy of Leslie Tulloch)

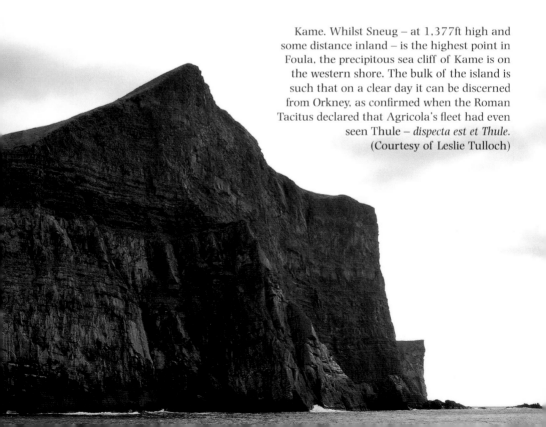

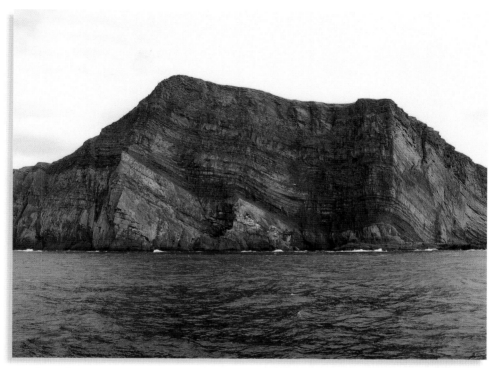

North Stack. Continuing north along the shore, North Bank is a continuation of the high cliffs that are an unforgiving feature of the west side of Foula. (Courtesy of Leslie Tulloch)

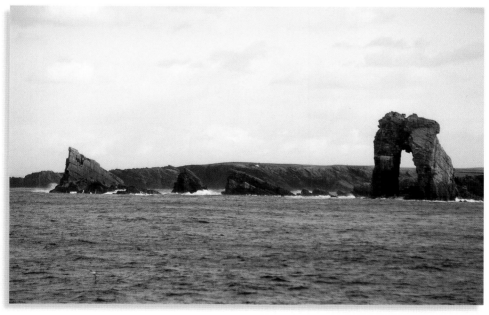

Gaada Stack. The untrammelled force of the Atlantic Ocean is graphically illustrated by the natural formation of Gaada Stack and the jagged outcrops at the extreme north end of Foula. (Courtesy of Leslie Tulloch)

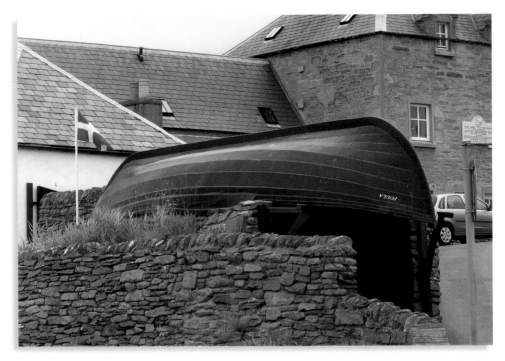

The former Foula ferryboat, *Advance LK*, makes a novel roof to a garage. This boat was built by the well-known Hamnavoe boat builder Walter Duncan in 1908 and often made the hazardous trip from the west side of Shetland to Foula across the open ocean.

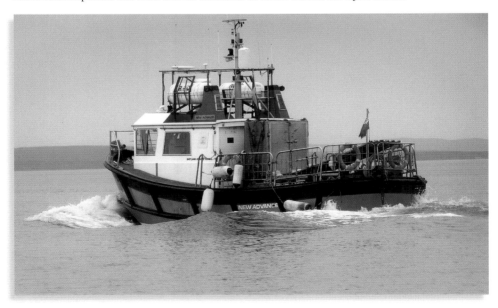

In contrast, the modern *New Advance* motors out from Scalloway bound for Foula, with a loaded container no doubt packed with a wide variety of goods necessary for the sustenance of the islanders on this remote outpost. Fitted out at Stromness, on a GRP hull built at Penryn, she entered service on 12 November 1996.

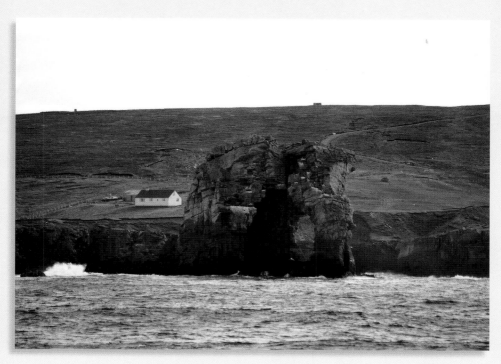

Gaada Stack. The shattered remains of an outcrop from the nearby shore, which holds an isolated homestead, linked to the more populous middle of the island by a road snaking up the hill. (Courtesy of Leslie Tulloch)

Tingwall has a special place in the history of Norse occupation, as it was there, on the promontory at the northern end of Tingwall Loch, that the annual lawting was held for almost 800 years, finally ending in 1604.

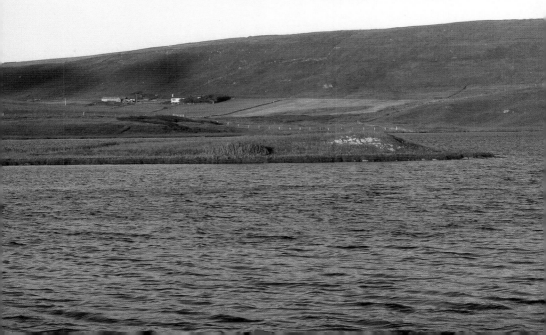

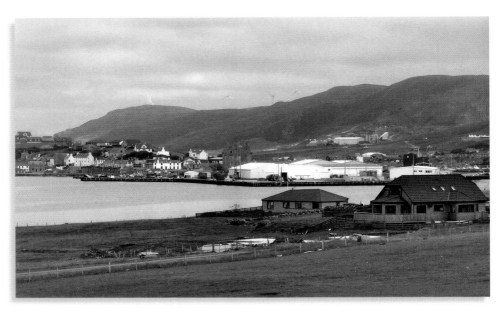

A view of Scalloway from Trondra. Windmills can be noted on the hill above the scarred hillside of the massive Scord Quarry. The large pink building to the left is the Old Haa, built around 1750 for the Scott family of merchants. Blacksness Pier has been greatly extended and much of the foreshore is covered with industrial buildings. The modern, wooden buildings on Trondra are fairly typical of many of these and have replaced the traditional but-and-ben cottages.

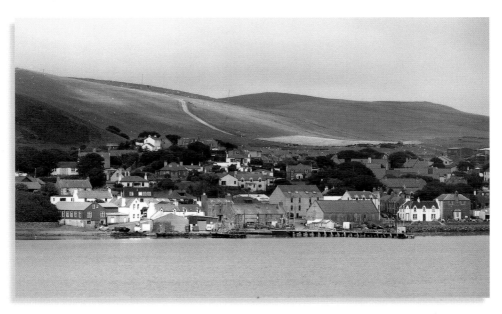

The Prince Olav Slipway and boat-repair yard is at the west-shore end of Scalloway, with the road to Burwick, which lies just over Gallow Hill. The red building is known as Norway House and was used as accommodation for Norwegians running the 'Shetland Bus' operation in the Second World War. The dark building with small porch is the Church of Scotland, completed in 1841. The shore road continues along to the left, leading out to Port Arthur and the Atlantic College.

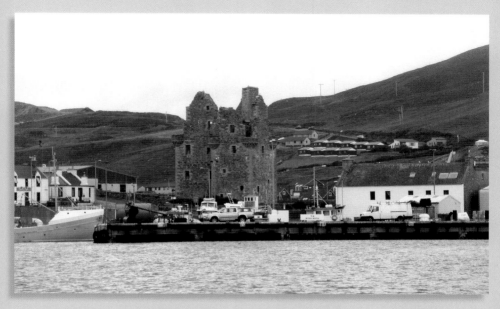

There are few castles in Britain currently in the midst of the kind of residential, commercial and industrial development exemplified by Scalloway Castle here. A cluster of chalets and dwellings are creeping up the hill beyond. The sharp bend in this road also has a lay-by with a well-known and popular viewpoint out over the seascape and island to the west of Shetland.

Scalloway, from the popular viewing point above the Scord, which provides unrivalled views out to the west. The castle is now dominated by the warehouses, stores and fish houses of Blacksness Pier. The Atlantic College at Port Arthur can be seen at the far right, the aptly named Green Holm is in the middle distance and Trondra appears to the left of the picture. The shore at the East Voe is now site to houses and a yacht marina.

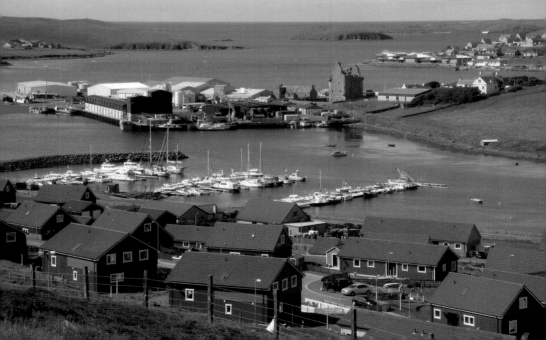

The memorial depicts *Andholmen*, a typical boat used to run the Shetland Bus operation between Shetland and Norway during the Second World War. The stones around the plinth were gathered from various places in Shetland and Norway that were associated with the Shetland Bus.

## ALT FOR NORGE

| NAME | AGE | DIED | BOAT |
|------|-----|------|------|
| JOHN LODDEN | 26 | 1942 | AKSEL |
| OVE ÅLEN | 21 | 1942 | AKSEL |
| OLAV SKARPENES | 49 | 1943 | BODØ |
| OLA GROTLE | 27 | 1943 | FEIØY |
| ANDREAS GEITERØY | 23 | 1943 | FEIØY |
| ULF T. V. JOHANSEN | 25 | 1943 | FEIØY |
| JOHAN KLUNGRESET | 27 | 1943 | FEIØY |
| HARALD NOTØY | 20 | 1943 | FEIØY |
| WALTER OLSEN | 23 | 1943 | FEIØY |
| ROALD STRAND | 25 | 1943 | FEIØY |
| HANS H. ØVRETVEIT | 23 | 1943 | FEIØY |

A plaque in memory of some of those who were lost on the hazardous passages fleeing from the German occupation of Norway.

Whilst common in Norway and Faeroe, this type of house is unusual in Shetland. It is a modern adaptation, which harks back to the days when numerous houses were thatched with straw.

An early morning arrival at Lerwick is lit up by the sun rising in the east. At this time the three large buildings were the Carnegie Boys' Hostel, the Anderson Institute (the only senior secondary school in Shetland, built and endowed in 1862 by the Shetlander Arthur Anderson – one of the founders of the P&O shipping line) and the Bruce Hostel for girls, opened in 1923.

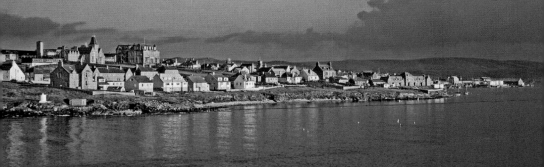

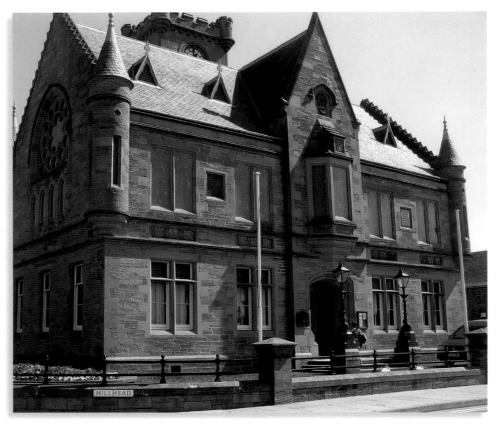

The foundation stone for the Lerwick Town Hall was laid by the then Duke of Edinburgh on 24 January 1882 when a tender of £3,240 was accepted. It was formally opened on 30 July 1883; however, many fittings were not included and the final cost was £4,940 15s 6d when, in 1884, it was virtually complete.

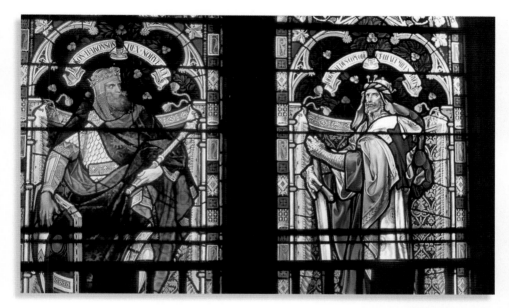

The glass windows on the north side of the Town Hall were considered a fitting decoration for the impressive building. The subcommittee who commissioned these impressive stained-glass windows were keen to include images depicting the history of the town and Shetland's Norse past.

This handsome building, situated in a dominant position on King Harald Street, was formerly the Lerwick Central Public School and catered for primary and secondary pupils. It was converted into a community centre in 1978–80 and provided a wide range of activities, including a popular cafe restaurant on the ground floor. The tower is a later addition.

Lodberry. In the late eighteenth and early nineteenth centuries, Lerwick saw a great expansion in trade and the movement of goods. This led many merchants to construct their own lodberry or pier store (the old Norse is *hjadberg*, which literally means 'loading rock') at the south end of town to keep and sort merchandise. However, this also naturally facilitated smuggling, with numerous underground passages leading from the head of the lodberry to surface some distance away. Many of these passageways were discovered inadvertently when new streets were formed.

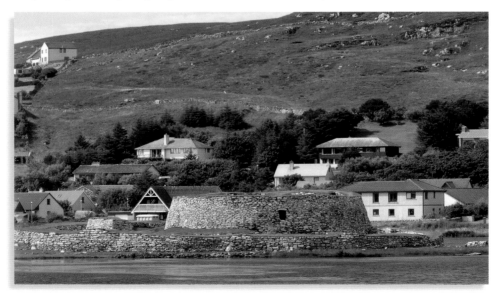

The Iron Age drystone structure of Clickimin Broch was built around 100 BC on an island connected to the southern shore of the Clickimin Loch. There is evidence of earlier Bronze Age occupation nearby, with a small farmhouse which is believed to go back to 1000 BC.

Hill Lane – one of a number of narrow lanes that extend from Commercial Street up to the Hillhead at Lerwick. These streets – including Pitt Lane, Hangcliff Lane, Navy Lane, etc. – often take their name from famous personages or events. At one time owned by many of the prominent businessmen in the town, today most of the smaller, cramped houses have been enlarged or modernised.

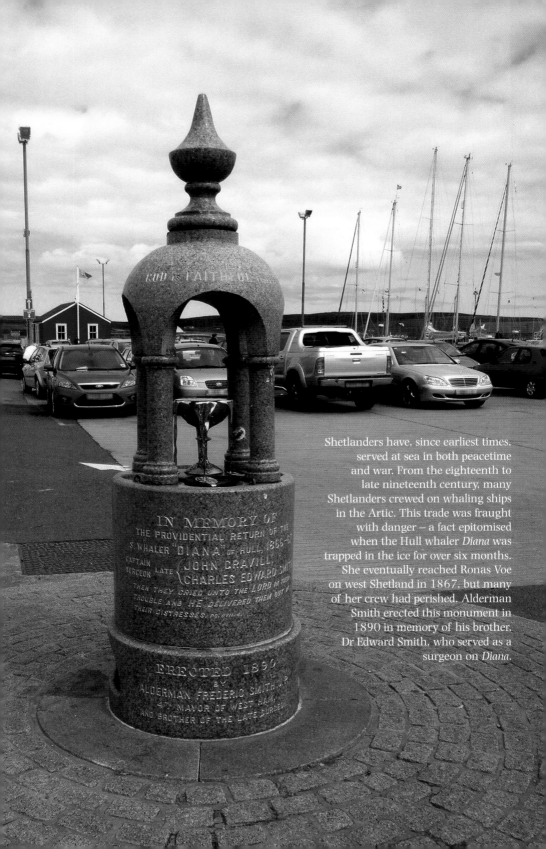

IN MEMORY OF
THE PROVIDENTIAL RETURN OF THE
S. WHALER "DIANA" OF HULL, 1866-67.
CAPTAIN LATE JOHN GRAVILL
SURGEON CHARLES EDWARD SMITH
THEN THEY CRIED UNTO THE LORD IN THEIR
TROUBLE AND HE DELIVERED THEM OUT OF
THEIR DISTRESSES. PS. CVII.

GOD IS FAITHFUL

ERECTED 1890
BY
ALDERMAN FREDERIC SMITH, J.P.
4TH MAYOR OF WEST HAM,
AND BROTHER OF THE LATE SURGEON

Shetlanders have, since earliest times, served at sea in both peacetime and war. From the eighteenth to late nineteenth century, many Shetlanders crewed on whaling ships in the Artic. This trade was fraught with danger – a fact epitomised when the Hull whaler *Diana* was trapped in the ice for over six months. She eventually reached Ronas Voe on west Shetland in 1867, but many of her crew had perished. Alderman Smith erected this monument in 1890 in memory of his brother, Dr Edward Smith, who served as a surgeon on *Diana*.

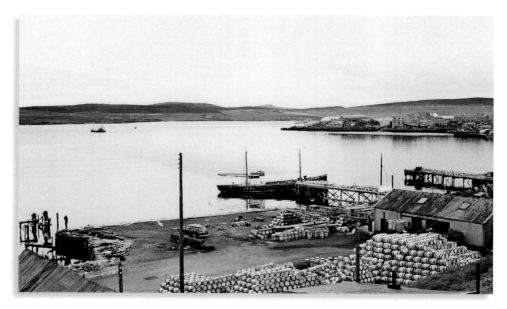

Only a vestige remains in this late-1960s photograph of the once-booming summer herring fishing industry, with its numerous curing stations extending from the west end of Lerwick to Gremista and beyond. The laid-up Zulu fishing boat *Research* was one of the last Shetland boats to use drift nets for herring. Her basic hull is now an exhibit in the fishing museum at Anstruther.

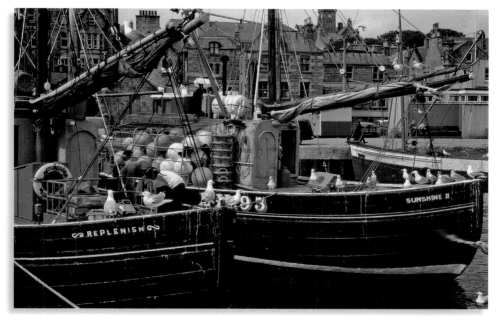

The sterns of two Hamnavoe-owned boats at Lerwick, at the tail end of the drift-net herring fishing season. The net bouys and herring creels are stacked on the decks of the *Sunshine II LK 93* and the *Replenish LK 97*. The men are probably preparing a 'fry' of herring, judging by the close attention of the herring gulls.

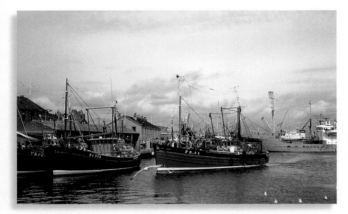

This image shows Scottish drift-net herring boats at the fish market during a period when this type of fishery was being phased out and replaced with the purse net.

The southern end of Lerwick. In days gone by, merchants favoured this location, where merchandise could be handled directly from the boats to their place of residence.

The small boat harbour at Lerwick. The white building, with a hairdresser's upstairs, was once the Royal National Lifeboat Institution (RNLI) stationhouse. The Queen's Hotel beyond has been in existence since the early 1860s and the new tolbooth, behind the frontage with red doors, was completed in 1767. It has served as a courtroom, customhouse, Masonic lodge and prison.

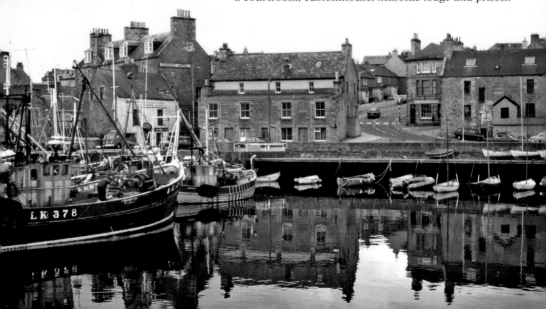

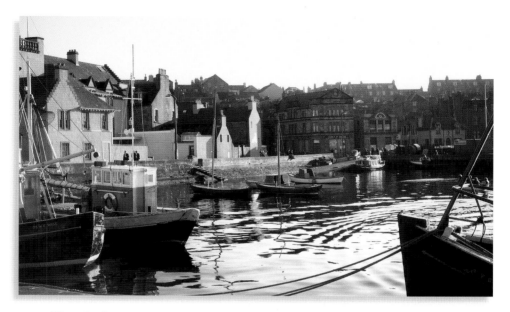

A small boat harbour at Lerwick, with the esplanade running along the seafront. The cream-coloured building with crow-stepped gables is the rear of the post office and the former Bressay ferry, *Brenda*, is lying in her berth at the slope in the corner of the harbour.

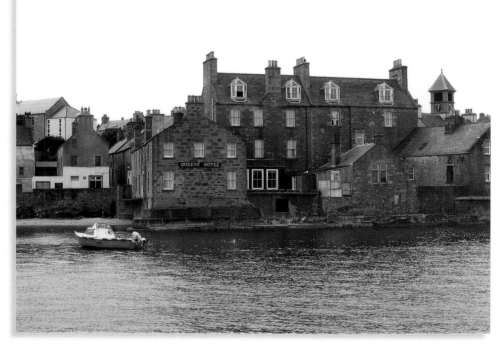

The Queen's Hotel at Lerwick has existed since the 1860s. It began as three lodberries and was developed into a hotel in this unique setting, projecting directly into the harbour.

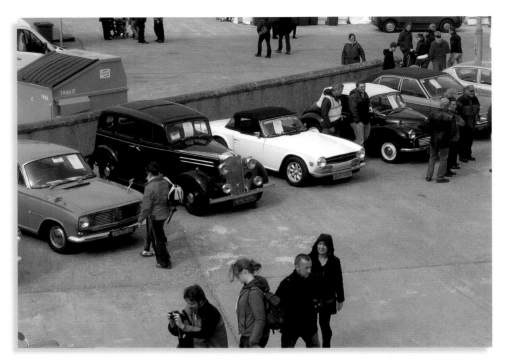

A vintage car rally at Lerwick. Oddly, none of the cars seen here display the former Shetland registration prefix of PS.

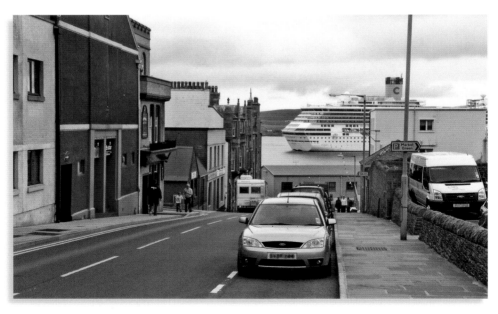

The stern of the Italian cruise liner *Costa Magica* is framed by the steep slope of Harbour Street, running down to Commercial Street. The red building is the former North Star Cinema; dating from 1913, it was the only such establishment on the isles at the time it operated. The imposing Brentfield buildings dominate the lower left-hand side.

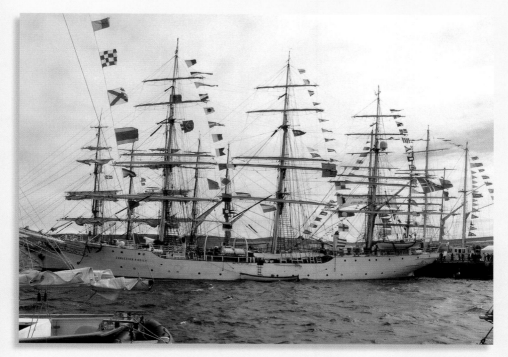

From 21–24 July 2011, Lerwick saw around thirty sailing ships of a large variety of types, ages and rigs during the extremely popular Tall Ships Races. The breezy conditions are highlighted by the snapping flags of the Norwegian training ship *Christian Radich*, built at the Framnaes Mekaniske Verksted in Norway and delivered on 13 June 1937.

Playing fields have been established close to the magnificent new sports centre at Clickimin, and cricket (once a novelty in Shetland) has now become popular, no doubt encouraged by the many so-called 'incomers'. It looks as though the ball is likely to be fielded at midwicket here.

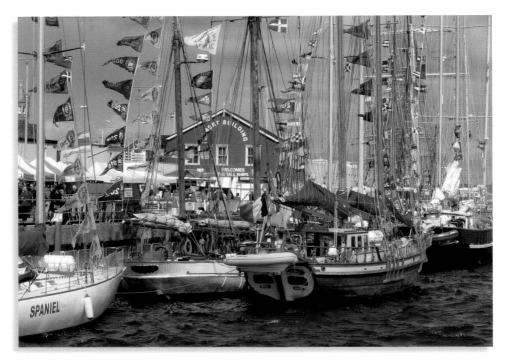

A mixture of traditional, old and new sailing vessels provide a colourful scene alongside the old fish market during the Tall Ships Races.

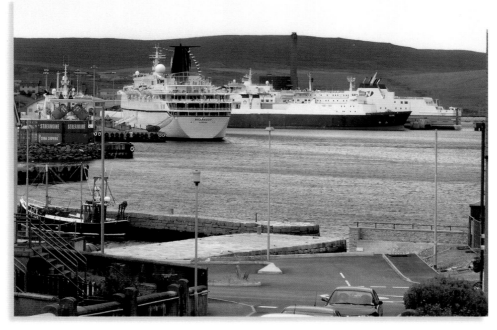

A busy scene at Lerwick with the cruise liner *Rhapsody* and vehicular cargo ferries *Clare* and *Hrossey* berthed.

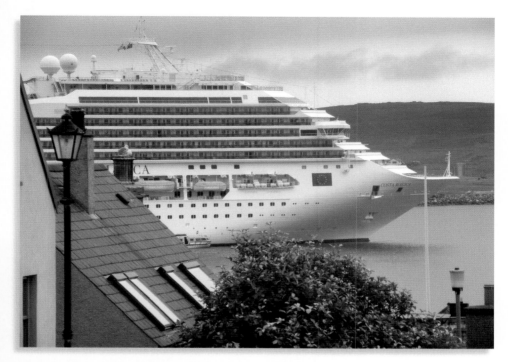

The sheer size of *Costa Magica* is evident in this snapshot view from Hillhead. She was launched on 1 December 2003, registered at Genoa, Italy and owned by the Carnival Corporation. She is one of the Fortuna class cruise ships, which can carry 3,470 passengers who are looked after by 1,072 crew.

*Costa Classica* is another of the Carnival Corporation's cruise liners, built by Fincantieri in Italy and seen here flying the Italian ensign. She can carry 1,680 passengers with a crew of 617. This ship was involved in two collisions – in 2008 and in 2010 – but without serious damage.

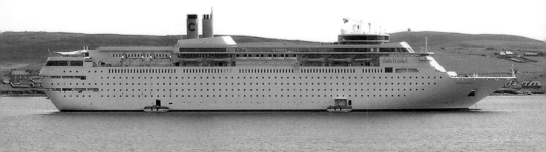

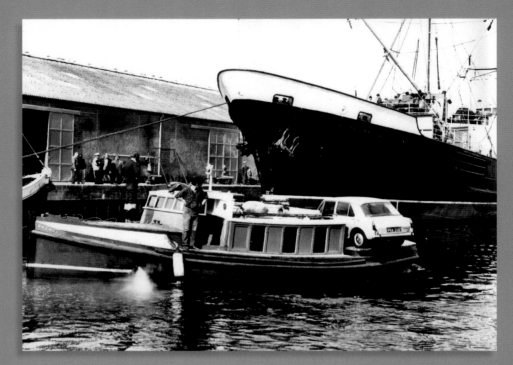

Where there is a will there is a way. The somewhat precarious perch of the car on the stern of *Brenda* is the subject of some interested observation by watchers on board and ashore. In a time before roll-on-roll-off ferries, the *Brenda* manfully carried out the crossing from Lerwick to Bressay. Reputed to have come from the German warship *Hindenburg*, scuttled at Scapa Flow at the end of the First World War, she soldiered on for many years. (Courtesy of Mrs Rosie)

*Rhapsody* leaving Lerwick. Built in 1977 by Burmeister & Wain in Copenhagen, this ship has sailed under a number of names, including *Cunard Conquest* until 1977; *Cunard Princess* until 1995; *Rhapsody* until 2009 and then *Golden Isis*.

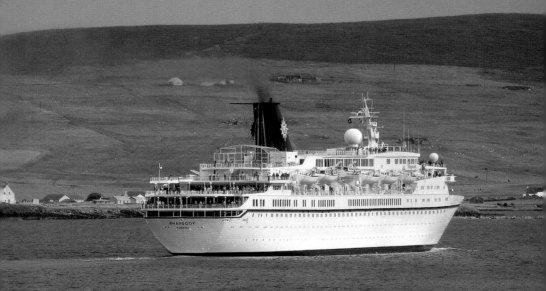

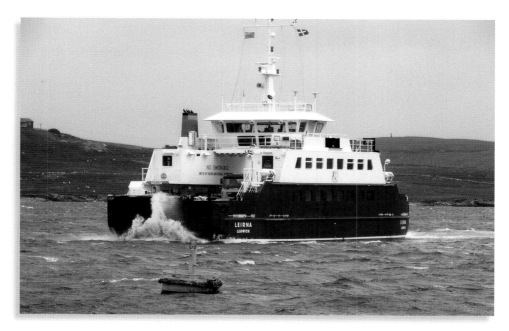

The double-ended Bressay ferry *Leirna* was completed by the Ferguson Brothers at Port Glasgow in 1992. In common with many similar routes throughout Scotland, the introduction of such purpose-built vessels has resulted in a significant increase in traffic, all of which has allowed residents of comparatively inaccessible islands to travel to the mainland for work and leisure.

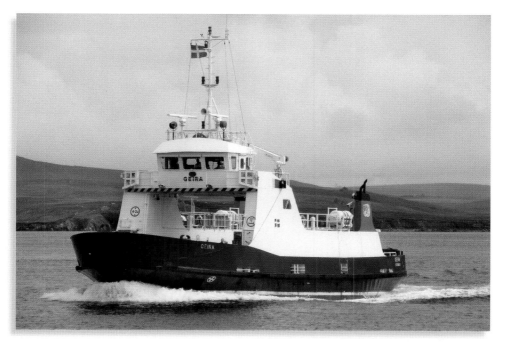

*Geira*, a ferry 30m in overall length, normally runs on the northern isles service, she was built in 1988, at the shipyard Richard Dunstons in Hessle, yard number 968.

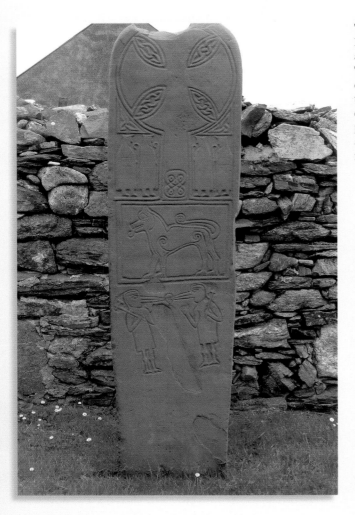

This is a replica of a Pictish cross stone found at Papil, West Burra. There are what looks like odd caricatures added at the base of the stone by a different carver, possibly poking fun at the bird-like appearance of the priestly figures above.

*Daggri* was launched at Gdansk, Poland on 17 December 2003. Used on the Yell Sound route, she has a capacity for thirty-one car units and 95/144 persons. Along with her sister-ship *Dagalein* (measuring 65.36m overall), these are the largest ferries in the Shetland Council fleet.

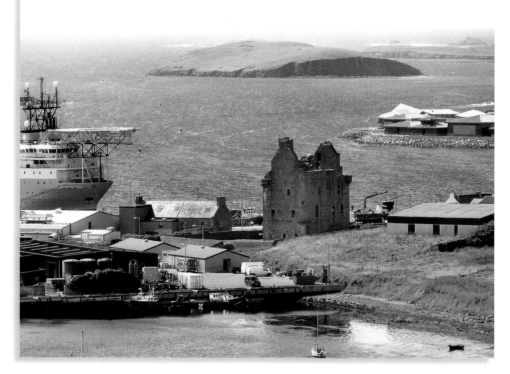

Scalloway Castle, built in 1600, is always associated with the tyrannical and wicked Earl Patrick. It is now somewhat overshadowed by the numerous industrial buildings which surround it. Green Holm is prominent in the distance, and Shetland's proximity to oilfields is confirmed by the offshore vessel *Mærsk Responder*.

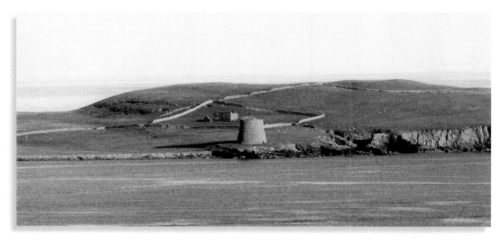

The Pictish Broch of Mousa is probably the best preserved of its type in Britain. Even with the top missing, it is still 43ft high, tapering from 45ft at the base to 39ft at the top. The red sandstone, drystone-walled, fortified building is still standing proud at over 2,000 years old. In the Icelandic sagas it is recorded to have been a safe haven for at least two Norse runaway lovers, but now its walls are an equally safe nesting place for storm petrels.

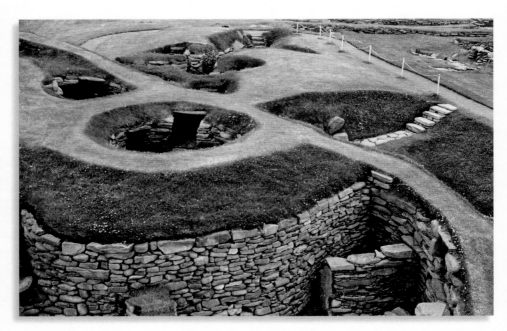

One of the so-called 'wheelhouse' structures at Jarlshof. These were built around the era of
broch building and, with others at nearby Scatness, are only to be found on the South Mainland.
The extensive pattern of buildings at the Jarlshof site display a mastery of the mechanics of
stone construction, a necessary skill owing to the lack of trees and suitable wood on the islands.

In the centre is the Sumburgh Hotel with the runways of Sumburgh Airfield behind.
On the promontory to the left is Jarlshof, which has been described as 'one of the most
remarkable archaeological sites' to be excavated in Britain. The settlement ranges from a
Stone Age hut, possibly 6,000 years old, to a 'modern' Viking homestead. The discovery
was made in the late 1800s when a storm washed away a cliff and revealed the site.

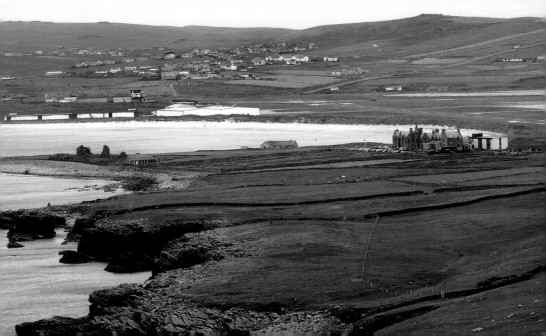

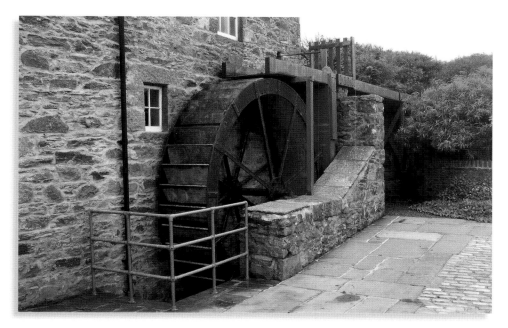

The Quendale Mill is about 4 miles north of Sumburgh Airport. Starting in 1868, the mill processed grain from crofts across a wide area, mostly operating in winter when water was plentiful. An overshot mill, with water flowing over the top, it continued in use until 1941 and has now been completely restored and operates as a visitor attraction, maintained by the South Mainland Community History Group. Quendale is thought to come from the Norse *kverndal* meaning 'mill dale', indicative of a long history of mills in the area.

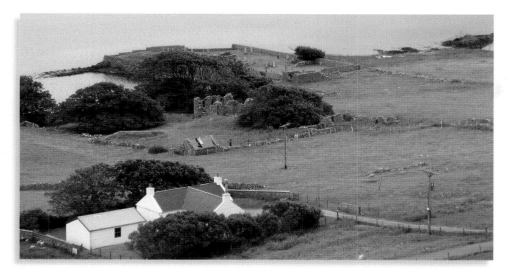

The rather nondescript ruin near the shore at Sound in Weisdale Voe is the house that belonged to John Clunies-Ross. Born into wealth, he served in the Royal Navy before becoming governor of the Cocos Islands, a post that would eventually see him take on the grander title of King of the Cocos. Near the ruins are the remains of an old harbour, yard and a church – known as the 'Da Aamis Kirk' – where gifts were once left in the hope that a special wish would be granted.

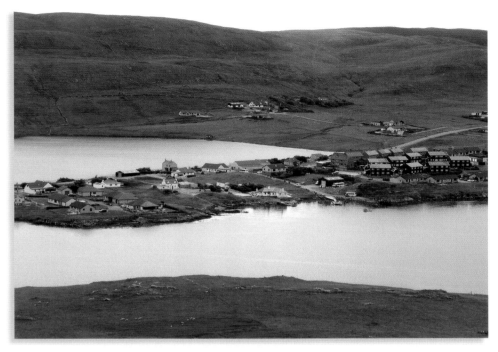

The 'narrow neck' stretching out of the picture provides a bridge between Loch Strom and Stromness Voe. Again we see a significant development of private and municipal houses which extend up the west side of the voe.

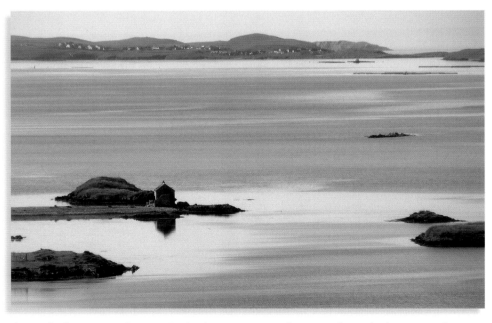

A view looking out to the mouth of Whiteness Voe, with Burra Isle on the horizon and salmon cages in the middle distance. The former stone-built fishing store, on the small projecting Point of Nesbister on the east side of the voe, has been converted to a camping Bôd.

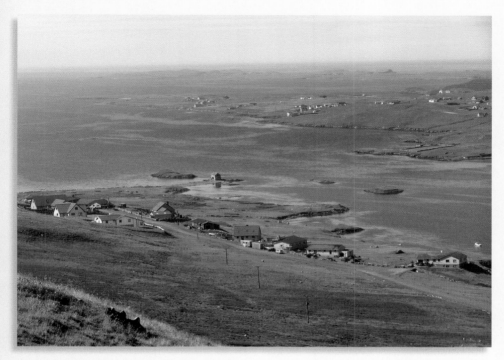

The viewpoints on the elevated bends in the road at Wormadale offer an ideal position for looking out to the west of Shetland. In the immediate foreground is the head of Whiteness Voe.

Busta House. This sheltered house on the west side of Busta Voe – with a frontage protected by substantial trees and the ambience of an English or Scottish mansion house – is now a hotel. It has had a chequered history, being once the home of wealthy traders, the Giffords, who owned large tracts of northern Shetland until their fortune was dissipated by prolonged wrangles over inheritance. During the First World War, Busta House was the headquarters for the admiral of the 10th Cruiser Squadron, tasked with blockading German ships trying to gain access to the Atlantic by going around the north of Shetland.

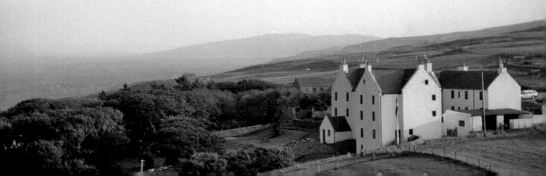

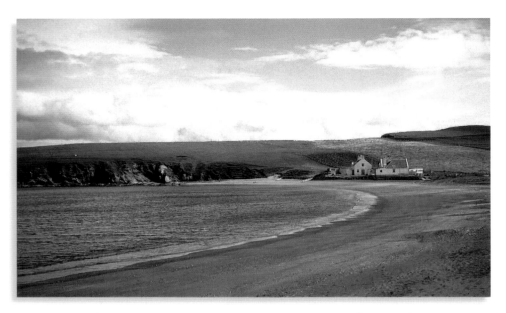

Reawick, with the distinctive curved, red sandy beach, was once a thriving fishing centre as evidenced by the buildings on the foreshore, which once incorporated shops as well as dwelling houses.

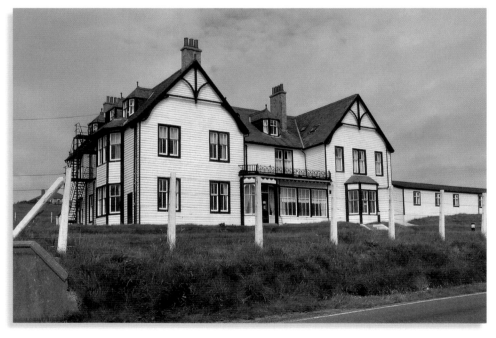

In 1900 the wooden St Magnus Hotel was erected at Hillswick by the grandly named North of Scotland, Orkney & Shetland Steam Navigation Co., using materials imported from Norway. Hillswick was once a landing place for passengers from the west-side sailing of the North Company. Near the beach is 'Da Bod' (The Booth), a restaurant bar, the building of which is first recorded in 1684 as Adolph Weterman's trading booth.

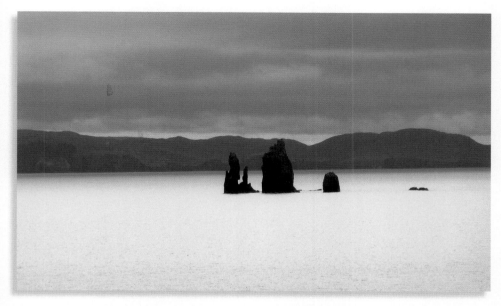

The snaggle-toothed and jagged profile of the Drongs lie at the north end of St Magnus Bay, half a mile offshore, and probably take their name from the Norse *Drangr* (a rock or peak). As with much of this coastline, the area is riven with rocky chasms and blowholes.

Off the southern end of Eshaness lies the spectacular Dore Holm, with its natural arch formed by exposure to the unceasing beat of the western ocean. The coastline in this area is particularly harsh and rocky, having experienced the full might of the unbroken fetch of the Atlantic.

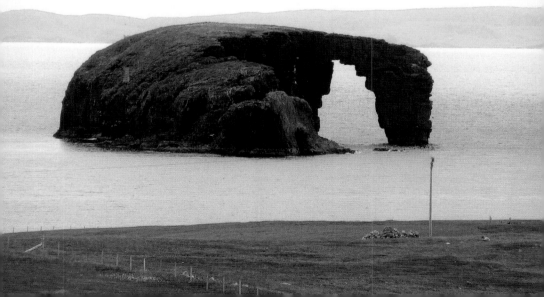

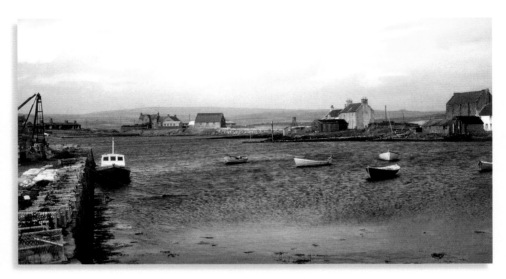

Walls, known as Waas in Shetland, sits at the head of Vaila Sound and was long used by the Foula ferry. Bayhall, the distinctive three-storey building at far right, has been restored and converted into flats, while the pier on the left-hand side forms part of the new yacht marina that extends out to the right. The blue Vaila ferryboat, *Curlew*, was built by Walter Duncan at Hamnavoe.

The heights of Vementry Island once guarded the Swarbacks Minn channel from attack. Derelict guns and lookout posts, installed during the First World War, mark where the northern blockading 10th Cruiser Squadron was based. At the highest point on the island are the finest burial cairns in Shetland.

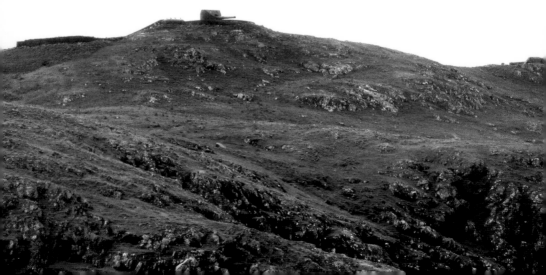

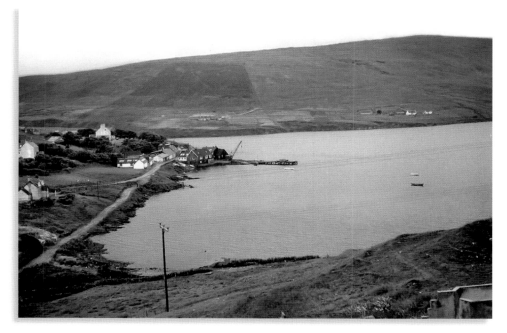

Voe, at the head of Olnafirth, has a long history of industry. There was once a herring station and, further down the firth, was a whaling station dating from 1904 until 1924. The local merchants, T.M. Adie & Sons, made jumpers from homespun wool, one of which was worn by Edmund Hillary during his climb of Mount Everest. Some of the old buildings have been converted into a bar and restaurant, and a marina has been added to the foreshore.

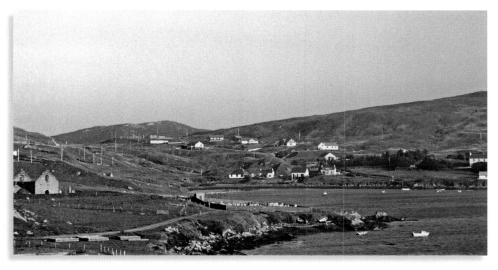

Looking to the head of Voe, with the spread of new modern houses straddling the access road. The ruins of the old Olnafirth kirk, which dates from 1714, can be seen on the left and, along with the kirkyard, extends right down to the shore. The village of Voe, at the head of the firth, lies as far inland from the open sea as it is possible in Shetland, indicative of the extended reach of the sea.

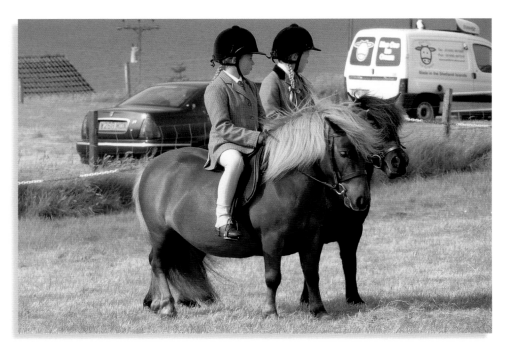

Unique to these islands is the Shetland pony. Their longevity and hardiness has evolved over the centuries to withstand the vagaries of Shetland weather, allowing them to survive on comparatively little sustenance. One of the smallest breeds of pony, they are now much sought after as mounts for children and not as beasts of burden. This photograph shows some groomed examples with well-matched riders, ready to parade for judging at a Voe craft and animal show.

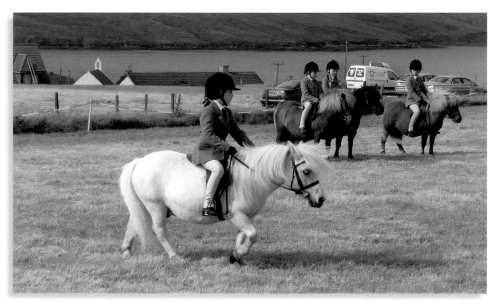

Formerly used for carrying items around the crofts, Shetland ponies are now predominantly bred for pleasure and recreation. Here they are immaculately presented for the judges' verdict at a Voe show in 2009.

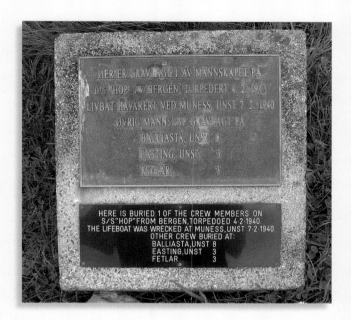

A memorial stone in the grounds of the Lunna kirk, marking the grave of one of the crewmembers of the Norwegian ship *Hop* which sunk on 4 February 1940.

Back on the east side of Shetland, the Lunna kirk (with inside dimensions of 34ft by 17ft) is the oldest building used for worship on the island. The current building dates from 1753 but certain aspects of the structure are much older, displaying similarities to the Unst kirk buildings, which date back to 1100–1200. Markers indicate the resting places of a number of those Norwegians who lost their lives during the Shetland Bus operations of the Second World War. These proceedings were largely co-ordinated by the nearby Lunna House.

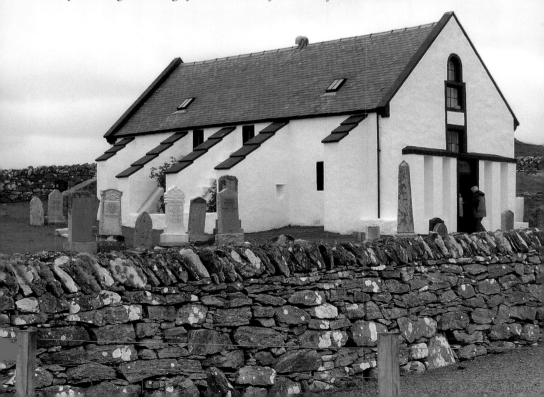

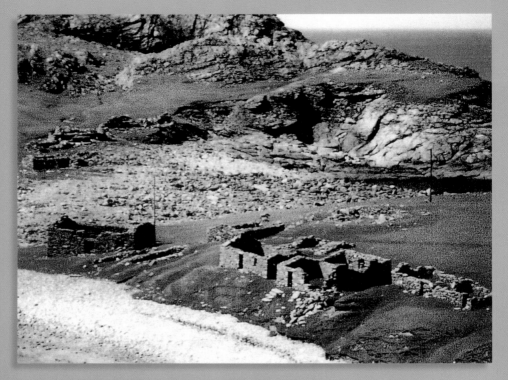

A number of ruined houses at Fethaland. (Courtesy of Hance Fullerton)

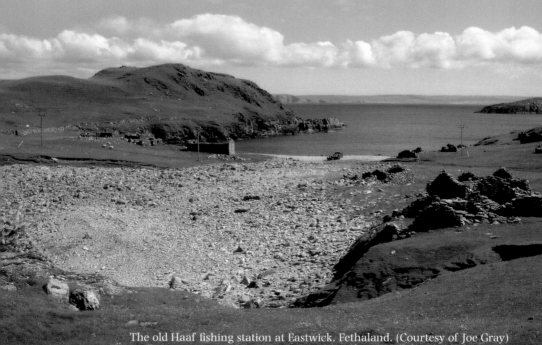

The old Haaf fishing station at Eastwick, Fethaland. (Courtesy of Joe Gray)

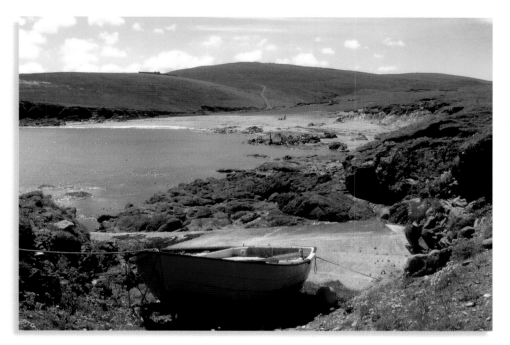

Skaw Beach, Unst, is the point which stands furthest north on the Shetland Mainland and can be reached by a track from the end of the A970 at Isbister, the most northerly termination of a public road in the UK. Twenty or so stone houses or booths remain here and are used during the summer haaf, sixern-line fishing, with up to sixty boats based here. (Courtesy of Joe Gray)

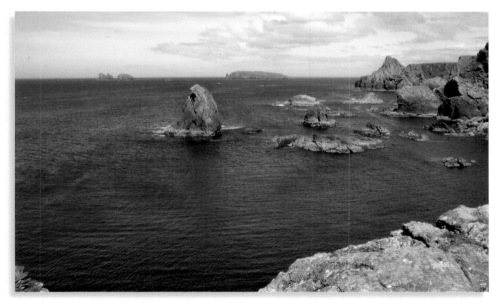

Nothing lies between the northern shore of Fethaland and the Arctic except the jagged outline of the exposed Ramna Stacks and the isle of Gruney with the light beacon. (Courtesy of Joe Gray)

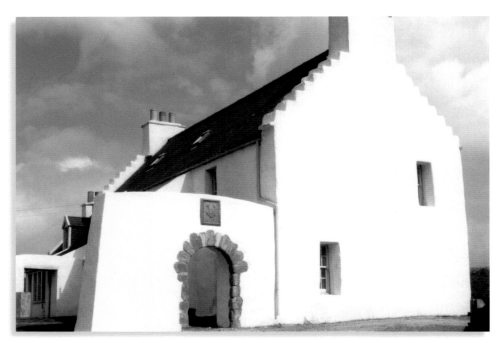

The Old Haa at Burravoe in Yell was originally built in 1672 by Robert Tyrie – a merchant who traded with Hamburg. When this activity was transferred to another building, nearer the shore, the site was tenanted. The archway at the side was once a passageway for the existing road between the haa and a linked building. The Old Haa has now been converted into a museum and contains many local artefacts and relics, including the collection of the late Bobby Tulloch, a well-known naturalist.

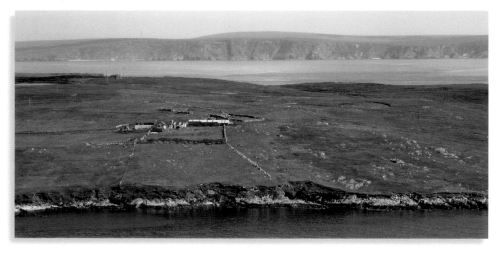

An isolated homestead on the north shore of the bay of Otterswick, Yell, with the cliffs of Fetlar in the distance. This was the scene of a shipwreck on 26 April 1924, when the German sailing barque *Bohus* – bound from Gothenburg to Taltal via Cape Horn – came inshore in bad visibility at the Point of Hatt on the Ness of Queyon. A figurehead, called the White Wife of Otterswick, was carved holding a bible and stands as a memorial to those four crew members who drowned in the shipwreck – the other thirty-five were saved due to the efforts of the islanders.

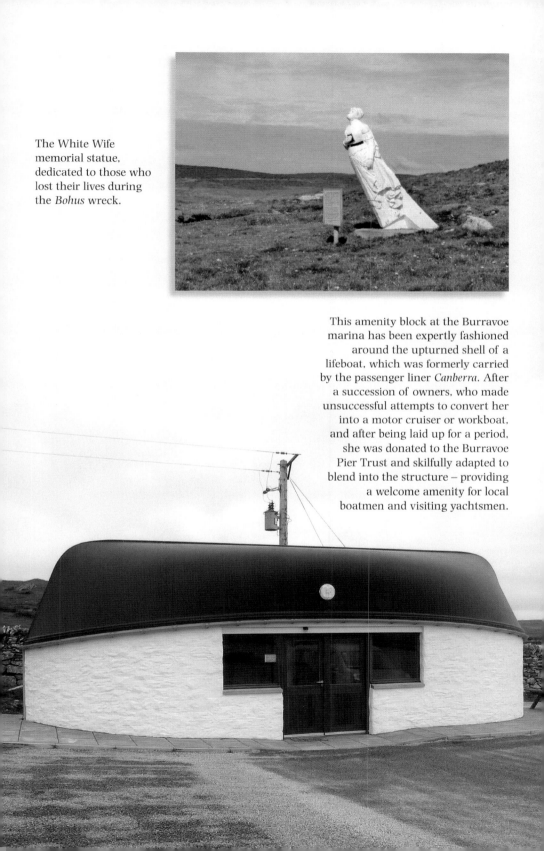

The White Wife memorial statue, dedicated to those who lost their lives during the *Bohus* wreck.

This amenity block at the Burravoe marina has been expertly fashioned around the upturned shell of a lifeboat, which was formerly carried by the passenger liner *Canberra*. After a succession of owners, who made unsuccessful attempts to convert her into a motor cruiser or workboat, and after being laid up for a period, she was donated to the Burravoe Pier Trust and skilfully adapted to blend into the structure – providing a welcome amenity for local boatmen and visiting yachtsmen.

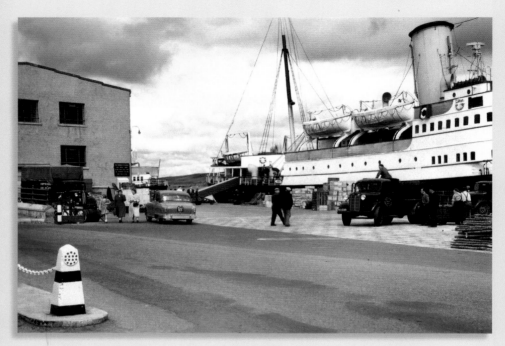

SS *St Clair* (I). Before the advent of roll-on-roll-off ferries on the Shetland–Aberdeen route, the SS *St Clair* provided the cargo and passenger link. She is berthed at the former fish-market quay, with the inter-island passenger cargo MV *Earl of Zetland* astern. Evidence of the varied nature of the cargo can be seen, the crane on the after deck is being manned and the passenger gangway is rigged aft.

St Ninian's Isle. Lying off Bigton, the isle can be reached by a sandy tombolo (or 'ayre' as they are called in Shetland), which has been formed by tides flowing around both sides of the back of the island. It was here – during excavations by students from Aberdeen University on the site of a Norse church with an early Christian or pre-Norse church below it – that a precious silver hoard was uncovered on 4 July 1958. The hoard was not discovered by a university student or a lecturer, however, but by a young boy. (Courtesy of Joe Gray)

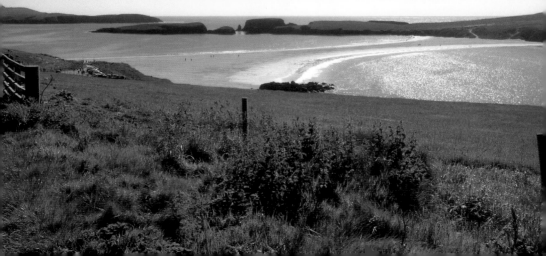

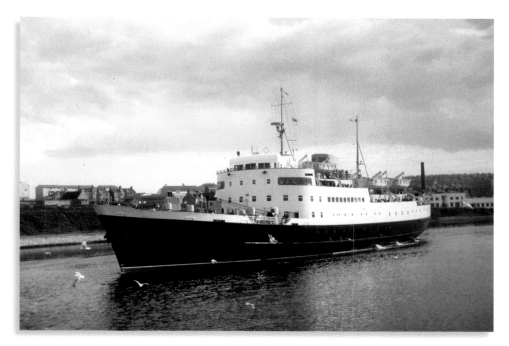

*St Clair* (III). Launched at Troon by Ailsa Shipbuilding on 29 February 1960, this magnificent vessel set new standards on the Aberdeen–Lerwick route, including using stabilisers. She was also the last of the traditional cargo-passenger ferries before the introduction of the roll-on-roll-off ships. She briefly bore the name *St Clair* (II) before the first car ferry entered service and she was finally laid up and sold to Kuwait owners in 1977.

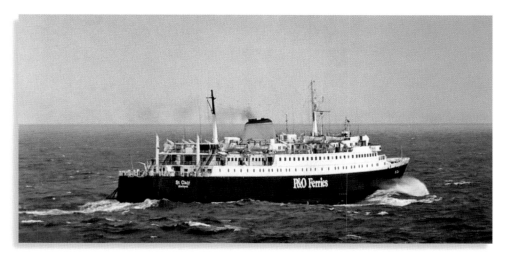

MV *St Clair* (IV). Entering service on 4 April 1977, this vessel introduced drive-on vehicular ferries to the Aberdeen–Shetland route. This necessitated the relocation of the Aberdeen terminal to Jamieson's Quay just off the town centre, and *St Clair* (IV) served under P&O Scottish ferries until 27 February 1992. Built at Lubeck in 1964 as the *Peter Pan*, she initially travelled between Oslo and Aarhus. In 1973 she ran on the Southampton–San Sebastian route and then, in 1976, she returned to her original route as *Terje Vigen*.

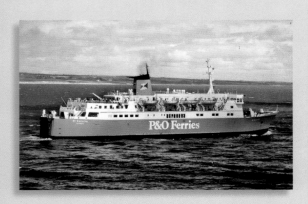

MV *St Sunniva* (III). The former P&O *Panther* was built at Helsingor in 1971 as *Djursland*, but on 28 November 1986 *Jasse* (II) entered the northern route after a £6 million major reconstruction by Hall Russell at Aberdeen. As *St Sunniva* she perpetuated a rather unfortunate name – the first *St Sunniva* was lost after becoming stranded on Mousa in April 1930, and the second capsized with the loss of all hands on 22 January 1943, very possibly as a result of severely icy seas.

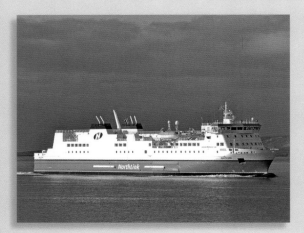

*Hjaltland* (old Norse for Shetland). Operated by Serco NorthLink Ferries since 5 July 2012, this roll-on-roll-off ferry was built – along with her sister *Hrossey* (old Norse for Orkney) – by Aker Finnyards at a cost of £35 million, and entered service in October 2002. With a capacity for 365 berths (in two- and four-berth cabins) and 140 cars, she is fitted with stabilisers and two bow thrusters, while her four engines are geared to twin VP screws capable of a speed of 24 knots. (Courtesy of Charley Umphray)

*Hrossey* in NorthLink's new livery, not to everyone's taste, however. (Courtesy of Ian Leask)

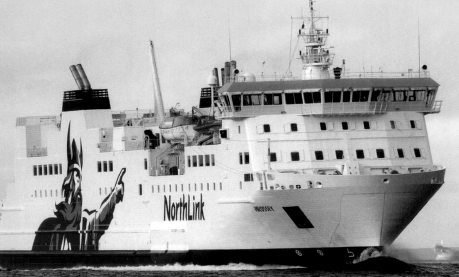

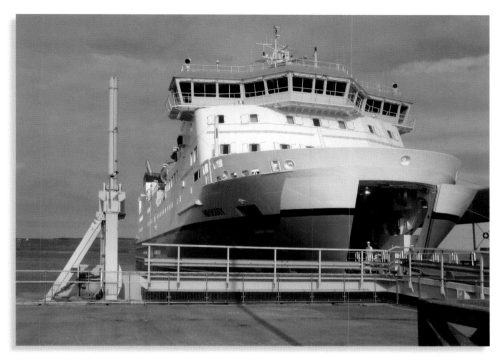

*Hrossey* at the Holmsgarth ferry terminal in Lerwick. The ferries now berth bow-in at Lerwick and stern-in at Aberdeen, so that vehicles can drive on and off without complicated manoeuvring and a 360-degree turn at either terminal. This is an improvement on their predecessors, which had bow doors that were sealed closed.

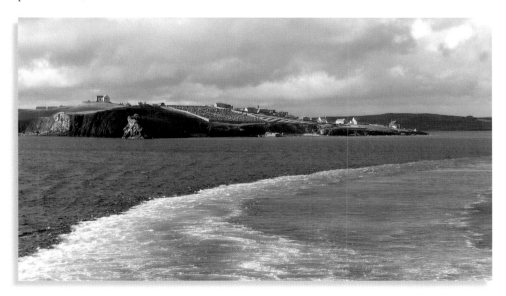

The wide swath of the wash of the ferry as she steadies on her course from Lerwick to Aberdeen. A cemetery is sited on the sloping shores of Knab, and there are also the remnants of those structures erected on the shore to house the ends of the protective barriers that stood across the South Mouth during the First World War.

A photograph captured while well under way south, past the Bard of Bressay with the isle of Noss (*Noss* being the Norse word for nose, appropriate to the pointed shape). This isle is a National Natural Reserve and serves as a breeding place and home to a myriad of seabirds. There are signs of habitation going back 4,000 years and there was still a population of twenty-four in the nineteenth century, although the last permanent resident left by 1939. A pony pund (enclosure) was built in the nineteenth century for mares, when the Marquis of Londonderry bred pit ponies there.

In 1858 the Stevenson brothers established the Bressay Lighthouse on Kirkabister Ness, at the South Mouth entrance to Lerwick. First lit on 31 August 1858, the fog signal was removed in 1987 and in 1995 it was purchased by the Shetland Amenity Trust to serve as a Marine Heritage Centre. On 12 September 2002, the 23-mile-range light was discontinued and a 10-mile LED light was erected by the port authority on the former radar station.

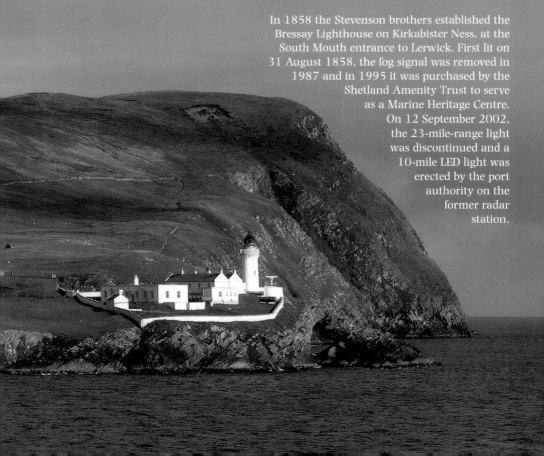

Lying about halfway between Orkney and Shetland, this island is known as Fair Isle but was named *Fridarey* (Isle of Peace) by Norse setters. This is an early morning shot, taken while travelling north on the ferry with relatively calm seas. The older name is given to the well-known Fair Isle knitting patterns and the island is equally famous for the bird observatory, established in 1948 and uniquely placed on the flight path between Scandinavia, Iceland and Faeroe.

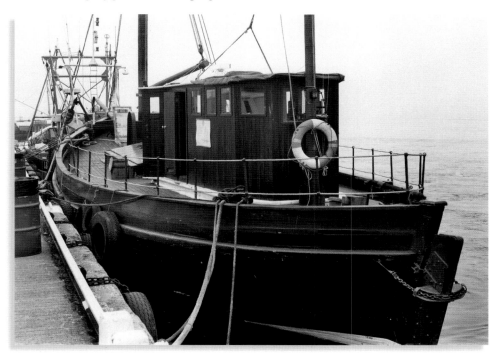

The Fifie fishing boat *Swan* was launched at Lerwick on 3 May 1900; originally serving as a herring lugger, she was converted to a smack rig in 1908. In 1935 she had an engine fitted before finally retiring as a seine-net boat in 1960, and being towed to Grimsby for conversion to a houseboat. By 1982 she was more or less lying derelict at Hartlepool, having sunk two or thee times. An attempt at restoration was made by a local businessman but, in the end, the *Swan* went up for sale. Fortunately, the Swan Trust was formed and arranged her purchase and eventual restoration. She was relaunched at Lerwick on 11 May 1996.

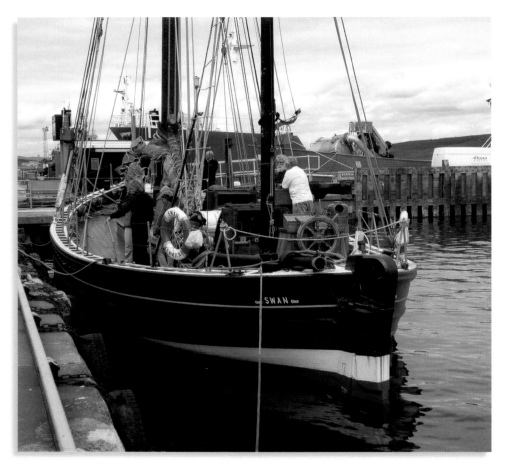

The *Swan*, a reminder of the numerous herring-fishing sailing boats around Scotland, is now fully restored but with an engine and modern interior. She began to operate commercially as a charter vessel in 1998 and has travelled widely around Britain, Europe and Scandinavia, taking part in a number of Tall Ships Races.

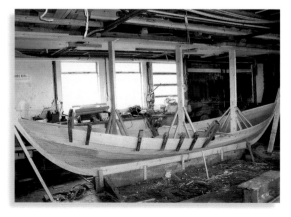

Tommy Isbister is one of the few remaining builders of wooden clinker, traditional 'Shetland Model' boats. Here he uses supports braced to an overhead beam to hold the planks in the required shape. Walter Duncan employed another method, using lateral strongbacks spaced at intervals along the length of the hull and tensioned by strong cords attached to hooks screwed into the top of the keel. Note the numerous clamps used along the planked sides. (Courtesy of Tommy Isbister)

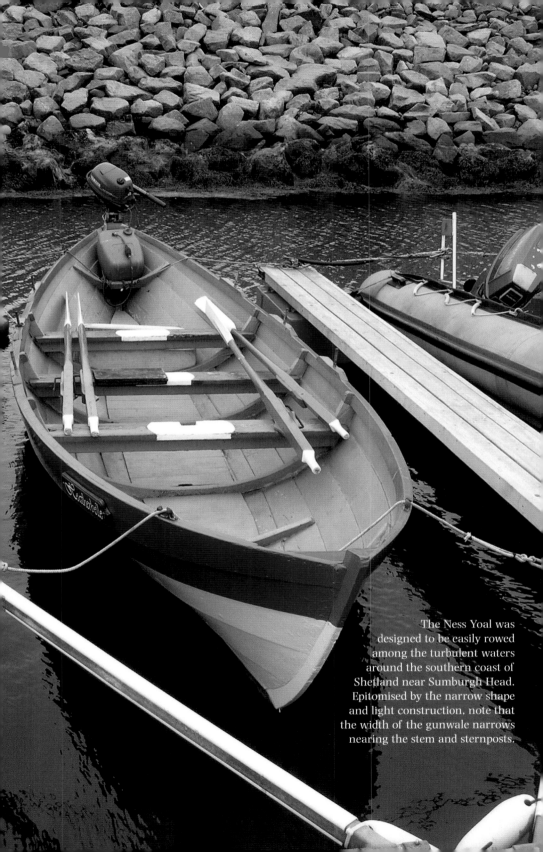

The Ness Yoal was designed to be easily rowed among the turbulent waters around the southern coast of Shetland near Sumburgh Head. Epitomised by the narrow shape and light construction, note that the width of the gunwale narrows nearing the stem and sternposts.

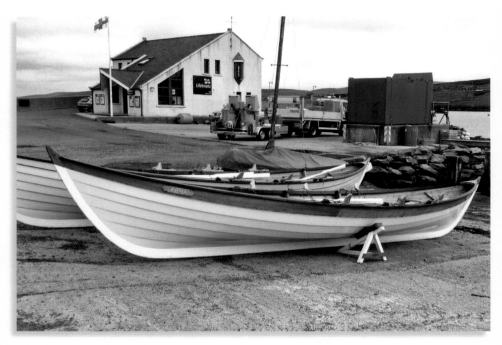

This rowing boat has some of the characteristics of a Ness Yole but has been intended for use in the rowing races that were very popular for a while.

In times past, it was necessary for the womenfolk of Shetland to be equally at home in rowing and sailing boats, and this tradition has been carried on in rowing races. This photograph shows the entrance of Hamnavoe on West Burra, with Fuglaness Lighthouse prominent.

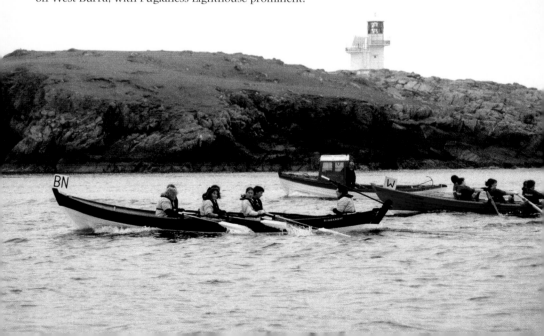

The start of a race off the beach at St Ninian's Isle in 2009; this time the boats are manned by a lusty crew of men.

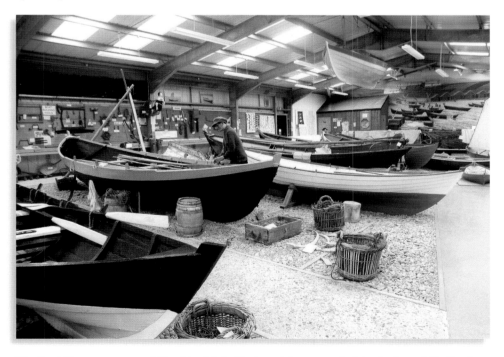

The Boat Haven museum at Haroldswick in Unst contains a wonderful selection of Shetland model boats and artefacts associated with the maritime past of Shetland. These include herring barrels, lobster creels, haddock line 'skôlls' and a variety of other traditional fishing equipment.

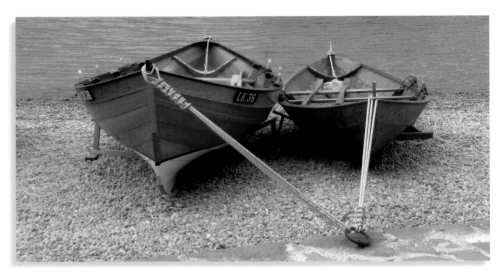

On the left is a typical boat of the locally called 'Shetland Model' type, with a greater number of narrow planks to the traditional pure Scandinavian type (seen on the right), which has three planks per side. Note the oars, which are carved from one timber; the characteristic kaebs (thole pins), which perform the same duty as rowlocks; and the rope humlibaands, which retain the oars when they are idling. The stammerin – the triangular-fashioned knee, linking the aft planking and sternpost – is common to both.

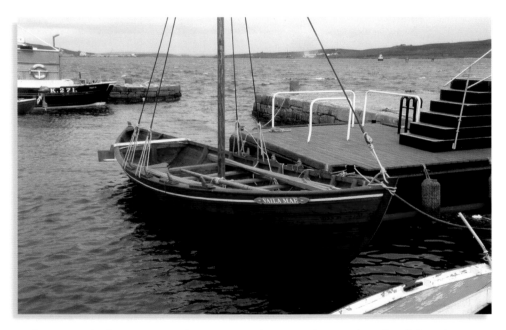

*Vaila Mae* was built to represent the sixern-type boats which carried out line fishing from stations around Shetland, often far out in the Haaf (Norse for ocean). These were gradually phased out with the introduction of half and fully decked boats bought from the north east of Scotland. A number of disasters, caused by summer storms that resulted in a large loss of life, hastened their demise.

The locally constructed beautiful *Dim Riv* commemorates the design of the famed Viking longship, complete with a dragon's head stem post. Appropriately, in the background a visiting modern yacht flies the Norwegian flag. The yacht is berthed at Victoria Pier, where the Shetland–Aberdeen ferry would once have tied up before the new development at Holmsgarth, further west along the shore, to cater for the roll-on-roll-off vessels.

*Dim Riv* under sail. If it wasn't for the fact that the crew are wearing modern clothing and lifejackets, this could be representative of a similar scene in the tenth century when the Scandinavian influence was all-pervading. *Dim Riv* is manned by volunteers and provides trips under sail in Lerwick Harbour.

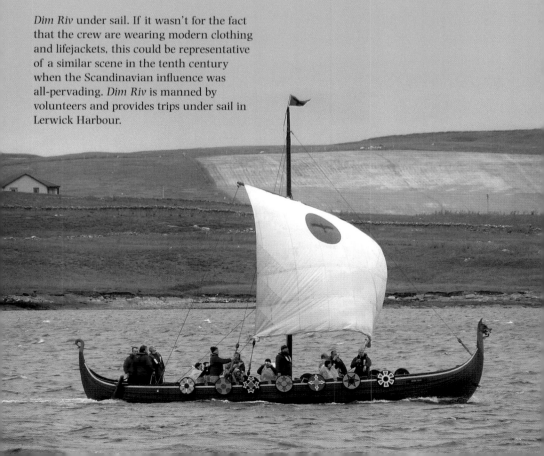

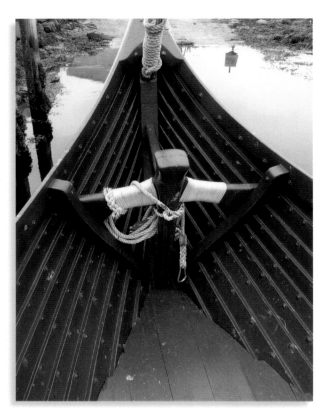

The modern *Dim Riv* was launched in 1980.

Another view of the perfect run of planking on *Dim Riv*.

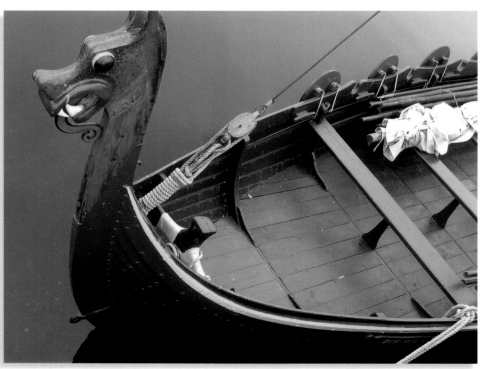

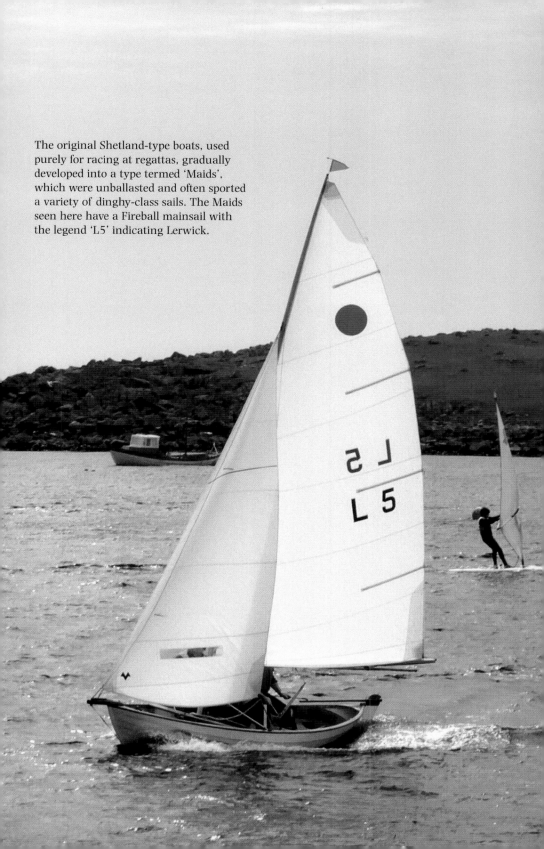

The original Shetland-type boats, used purely for racing at regattas, gradually developed into a type termed 'Maids', which were unballasted and often sported a variety of dinghy-class sails. The Maids seen here have a Fireball mainsail with the legend 'L5' indicating Lerwick.

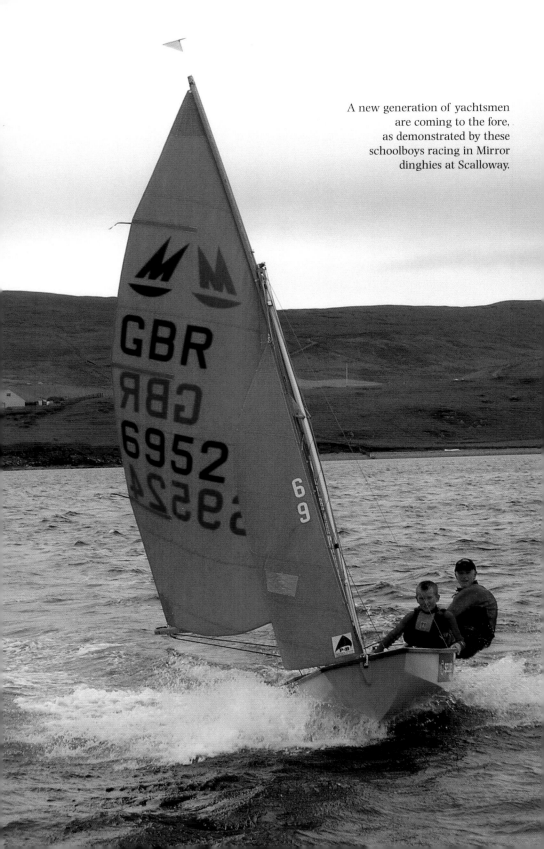

A new generation of yachtsmen are coming to the fore, as demonstrated by these schoolboys racing in Mirror dinghies at Scalloway.

The gradual adoption of inboard engines in traditional Shetland-type rowing and sailing boats has led to the construction of true powered boats, with increasing beam and displacement to compensate for the additional weight and power. This is demonstrated in the *Auk*, built by Walter Duncan at Hamnavoe.

*Utilise* was built purely as a powered, versatile fishing boat, albeit retaining the characteristics of the true Shetland Model design.

An example of the modern whitefish trawler now universally adopted by Shetland fishermen is the *Fertile*, a far cry from the small open boats such as the sixern *Vaila Mae* that reigned supreme in the earlier days of deep-sea fishing.

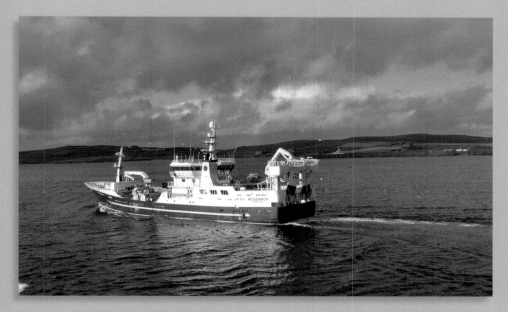

The ultimate embodiment of the fish hunter is the state-of-the-art pelagic trawler *Research*. Built in 2003 and perpetuating a succession of such names – which stem from a Zulu herring drifter which is now partly in a preservation status at the Fishing Museum at Anstruther – the *Research* is designed to fish for a variety of deep-sea species, landing her catch anywhere in Northern Europe and Scandinavia as market trends demands.

A new role, which Shetland fishermen are ideally suited to perform, is in the transportation of salmon smolts. They are taken from the hatchery and reared in enclosed cages sited in many suitably sheltered, clean-water locations around the deeply indented coast of Shetland. The *Norholm* is typical of these vessels, with internal free-flooding storage tanks and pumping machinery for discharging and loading smolts.

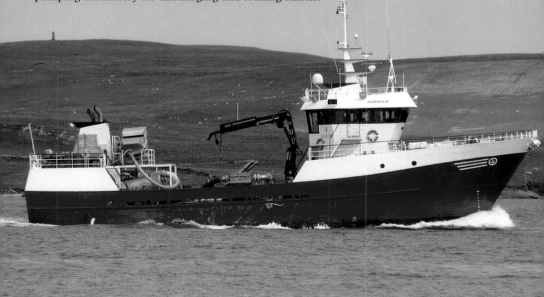

The Aith Lifeboat Station, on the west coast of Shetland, is the most northerly in the UK and was established in May 1933. The loss of trawler *Ben Doran*, on the Vee Skerries in March 1930, emphasised the need to protect ships along the western coast of the islands. The new pier was opened in 1986 and a new shore station and base house in 2003.

My painting is a montage of just three of the different classes of lifeboats that have served the station: a Barnett-class *John and Frances Macfarlane*, Arun-class *Snolda* and Severn-class *Charles Lidbury*.

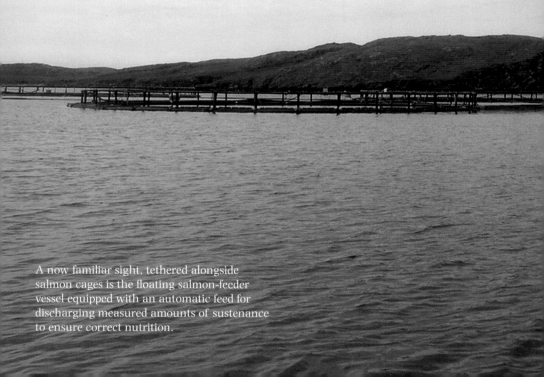

A now familiar sight, tethered alongside salmon cages is the floating salmon-feeder vessel equipped with an automatic feed for discharging measured amounts of sustenance to ensure correct nutrition.

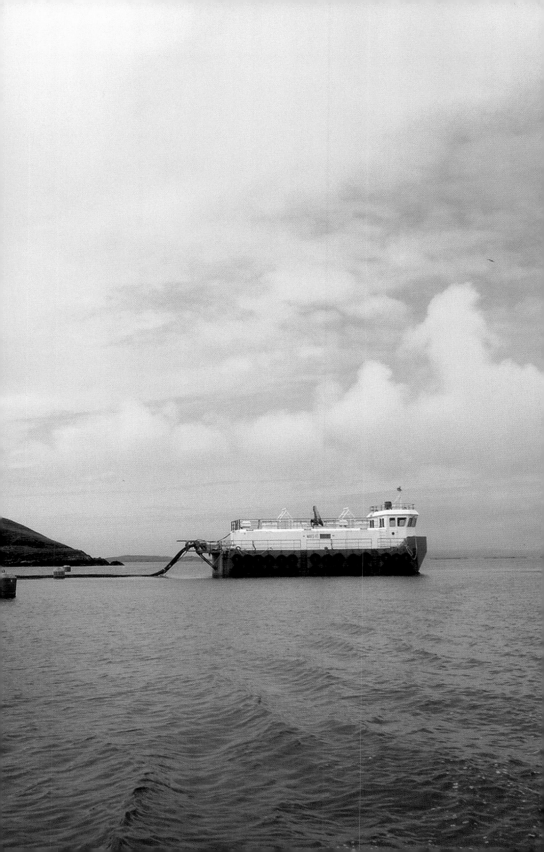

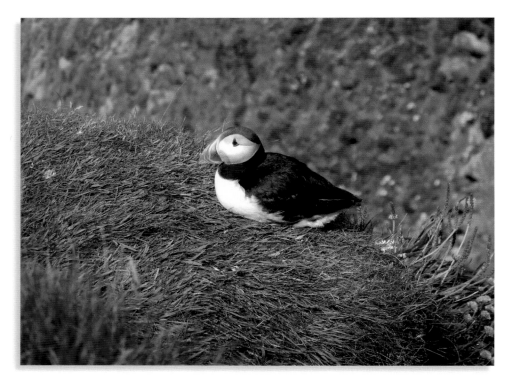

The much-loved puffin, locally known as a 'tammie norie', is a member of the Auk family. It is estimated that there are about 1 million pairs, which form 20 per cent of the UK puffin population. With their nests in burrows, they are often preyed on by feral cats and ferrets, not to mention being waylaid by bonxies on their way back from the open sea with a beak full of sand eels. (Courtesy of Joe Gray)

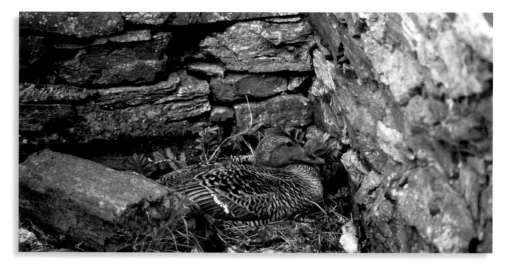

The eider duck, or dunter, is notable for their camouflage when sitting on a nest site and the very fine down used to line their nests. Some of their eggs are robbed for boiling and some young dunters are taken to be reared and supposedly tamed at home.

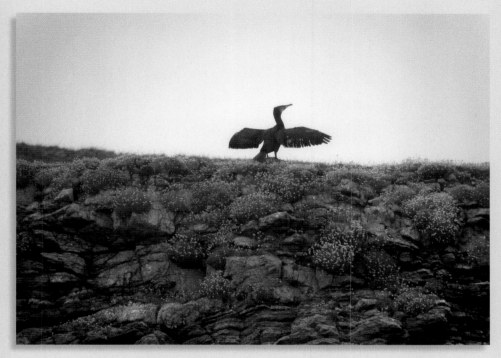

'Skarf' is the local name given to the cormorant and shag, which have been common in Shetland since at least as far back as the Bronze Age. They breed on rocky shores and stacks to the west side of Shetland and one holm in Yell Sound. It is a common sight to see them spreading and drying their wings on a rocky outcrop.

Skarfs on the south shore of Havra, with a black-backed gull preening nearby.

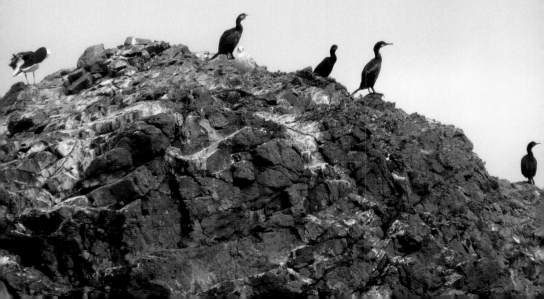

The rather ugly face of the grey seal, with its Roman nose and high muzzle. A common visitor to harbours, their predations are not limited to discarded fish and offal, and increasingly they are accused of taking enormous numbers of prime, marketable fish.

The most common whale seen in Shetland waters is the menacing-looking killer whale; this one was sighted with a calf at Whalwick in Eshaness. Formerly hunting offshore, they have recently moved inshore to areas frequented by seals, a favourite in the killer whale's diet. (Courtesy of Joe Gray)

A view from the ferry travelling south, as Sumburgh Head catches the evening sun.
The last sight of Shetland for many exiles: some, sadly, never to see it again.

If you enjoyed this book, you may also be interested in…

### Wooden Fishing Boats of Scotland

JAMES A. POTTINGER

With the gradual phasing out of wooden fishing boats in Scotland, it is timely to record some of these handsome vessels. In the years from 1960–80, boat-builders produced some of their most shapely and graceful craft, a testament to the skill of both the builders and designers. Many of the boats in this volume were photographed at sea, while other views range from repairs being carried out to the more melancholy sight of beautiful craft being dismantled.

978 0 7524 8757 1

### Clyde Built Ships

JAMES A. POTTINGER

For many years the River Clyde held a premier place in the world of shipbuilding and engineering, pioneering many advances in both disciplines. Whilst these days are long gone, we should never forget the great contribution made by a range of companies, from those constructing luxury passenger liners and major warships, to those building a whole range of cargo ships and the smaller concerns concentrating on coasters, tugs, dredgers and puffers. This illustrated history reveals the whole gamut of Clyde-built types constructed on the river and celebrates the glory days of times past.

978 0 7524 8999 5

### Orkney's Lifeboat Heritage

NICHOLAS LEACH

The seas around Orkney and the Pentland Firth are amongst the most dangerous and perilous of any in the world. The volunteer lifeboat crews of Orkney have performed many incredible, courageous and daring rescues, manning the lifeboats to save lives from stricken vessels. Beautifully illustrated, this volume looks at the lifeboats of Longhope, Stromness, Kirkwall and Stronsay.

978 0 7524 3896 2

Visit our website and discover thousands of other History Press books.

**www.thehistorypress.co.uk**